B. "Moose" Peterson Nikon Lenses

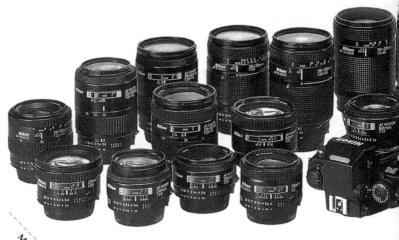

Aggic land Childs College

B. "Moose" Peterson

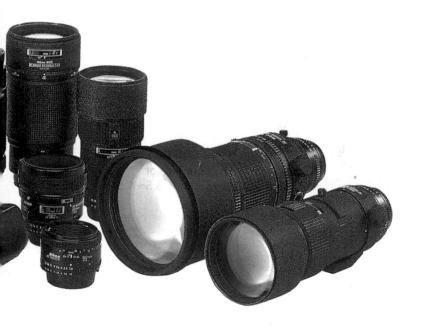

Laterna magica

Magic Lantern Guide to **Nikon Lenses**

A Laterna magica® book

First Edition February 1994 Published in the United States of America by

> The Saunders Group 21 Jet View Drive Rochester, NY 14624

Written by B. "Moose" Peterson
Production Coordinator: Marti Saltzman
Editorial Assistant: Mimi Netzel
Layout and Design: Buch und Grafik Design Günther Herdin
Assistant: Michaela Schemmerer, Munich
Printed in Germany by Kösel GmbH, Kempten

ISBN1-883403-07-3

®Laterna magica is a registered trademark of Verlag Laterna magica Joachim F. Richter, Munich, Germany under license to The Saunders Group, Rochester, NY U.S.A.

> ©1994 B. "Moose" Peterson The Saunders Group

©1993 Photos by B. "Moose" Peterson All product photos supplied by Nikon, GmbH and The Saunders Group Cover photo by Jake Paterson

®Nikon and Nikkor are registered trademarks of Nikon, Inc.

This book is not sponsored by Nikon, Inc. Information, data and procedures are correct to the best of the publisher's knowledge; all other liability is expressly disclaimed. Because specifications may be changed by the manufacturer without notice, the contents of the book may not necessarily agree with changes made after publication.

Contents

NI	kon Lens Terminology	. 9
	AIS Meter Coupling	
	Al and Non-Al Lenses	12
	Autofocus Lenses	13
	AF-I Lenses	15
	Internal Focusing (IF)	16
	ED Optics	
	Nikon Integrated Coatings (NIC)	18
	Close-Range Correction (CRC)	19
	Focal Length and Angle of View	20
	Definition of Terms	21
	Caring for Your Nikon Lens	26
Fis	heyes and Ultra Wides	28
	Tricks of the Trade	
	Watch Out for Strays	
	Vignetting	
	Making the Subject Pop	
	Nikkor 6mm f/2.8	
	Nikkor 8mm f/2.8	
	Nikkor 13mm f/5.6	
	Nikkor 15mm f/3.5	
	Nikkor 16mm f/2.8	
	Nikkor 16mm f/2.8D AF	
	Nikkor 18mm f/3.5	
	Nikkor 20mm f/2.8 AF	
Wi	de Angles and Normal Lenses	10
***	Tricks of the Trade	
	Proper Handholding Technique	
	Nikkor 24mm f/2	
	Nikkor 24mm f/2.8N AF	52
	Nikkor 28mm f/1.4D AF	
	Nikkor 28mm f/2	
	Nikkor 28mm f/2.8N AF	
	TYINNOL ZUHIHI I/Z.ON AF	90

Nikkor 28mm f/3.5 PC	57
Nikkor 35mm f/1.4	58
Nikkor 35mm f/2 AF	59
Nikkor 35mm f/2.8 PC	60
Nikkor 50mm f/1.2	62
Nikkor 50mm f/1.4N AF	63
Nikkor 50mm f/1.8N AF	65
T - -	
Telephotos	
Tricks of the Trade	
Isolating the Subject	
Compacting the Scene	
Flare	
Sharpness	
Nikkor 85mm f/1.4	
Nikkor 85mm f/1.8 AF	
Nikkor 105mm f/1.8	
Nikkor 105mm f/2D DC AF	
Nikkor 105mm f/2.5	
Nikkor 135mm f/2	
Nikkor 135mm f/2 DC AF	
Nikkor 180mm f/2.8N ED IF AF	
Nikkor 200mm f/2 ED IF	80
Super Telephotos	92
Tricks of the Trade	
Lens Speed	92
Filters	93
Focus Controls	96
Lens Shades	96
Super Telephoto Technique	96
Transportation	97
Nikkor 300mm f/2.8N ED IF AF	98
Nikkor 300mm f/2.8D ED IF AF-I	99
Nikkor 300mm f/4 ED IF AF	103
Nikkor 400mm f/2.8D ED IF AF-I	
Nikkor 400mm f/2.8 ED IF	
Nikkor 400mm f/3.5 ED IF	
Nikkor 400mm f/5.6 ED IF	108
Nikkor 500mm f/4 P ED IF	109

	Nikkor 600mm f/4 ED IF	
	Nikkor 600mm f/4D ED IF AF-I	
	Nikkor 600mm f/5.6N ED IF	114
	Nikkor 800mm f/5.6 ED IF	115
700m	s	110
	cks of the Trade	
1111		
	Variable f/stop Design	
	Macro Plus Versatility	
	Nikkor 20-35mm f/2.8D AF	
	Nikkor 24-50mm f/3.5-4.5 AF	
	Nikkor 28-70mm f/3.5-4.5D AF	
	Nikkor 28-85mm f/3.5-4.5N AF	
	Nikkor 35-70mm f/2.8D AF	
	Nikkor 35-80mm f/4-5.6D AF	
	Nikkor 35-105mm f/3.5-4.5N AF	
	Nikkor 35-135mm f/3.3-4.5N AF	
	Nikkor 35-200mm f/3.5-4.5	
	Nikkor 75-300mm f/4.5-5.6	
	Nikkor 50-300mm f/4.5 ED	
	Nikkor 180-600mm f/8 ED	
	NIKKOI 160-600HIIII I/O LD	140
Specia	ılty Lenses	148
Trie	cks of the Trade	
	Nikkor 58mm f/1.2 Noct	148
	Nikkor 60mm f/2.8 Micro AF	
	Nikkor 105mm f/2.8 Micro AF	
	Nikkor 105mm f/4.5 UV	154
	Nikkor 120mm f/4 IF Medical	155
	Nikkor 200mm f/4 Micro IF	
	Nikkor 500mm f/8N	158
	Nikkor 1000mm f/11	159
Teleco	onverters	160
	cks of the Trade	
1110	Nikkor TC-14A	
	Nikkor TC-14B	
	Nikkor TC-14E	
	THE TALL THE	100

	Nikkor TC-20E	167
	Nikkor TC-201	167
	Nikkor TC-301	168
"Olo	dies but Goodies"	170
	Nikkor 55mm f/2.8 Micro	170
	Nikkor 105mm f/4 Bellows Lens	174
	Nikkor 300mm f/2 ED IF	175
	Nikkor 300mm f/4.5 ED IF	176
	Nikkor 800mm f/8 ED IF	178
	Nikkor 1200mm f/11 ED IF	179
	Nikkor 25-50mm f/4	
	Nikkor 50-135mm f/3.5	182
	Nikkor 80-200mm f/4.5	
	Nikkor 200-400mm f/4 ED	

Nikon Lens Terminology

Each lens manufacturer has its own terminology to describe its lenses and Nikon is no exception. These terms describe either the process by which the lens is manufactured or special attributes particular to that lens. Many of these terms are unique, others are simply sales tools. But whatever the case, understanding these terms is necessary to be an informed buyer and user of Nikkor optics.

AIS Meter Coupling

In 1982 all Nikkor lenses were converted to the AIS system of meter coupling. With the exception of those found in Chapter 9, "Oldies but Goodies," all lenses in this book are current production models. Thus, they all have "AIS" (Aperture Indexing-Shutter) meter coupling. Some lenses which were first introduced in 1959, such as the 105mm f/2.5, have gone through many changes leading up to the current models. These changes have incorporated newer cosmetics, optics and, most importantly, AIS meter coupling.

The AIS system allows the camera body to determine the focal length of the attached lens. This is accomplished by a small scoop in the lens mounting flange. A small pin in the bayonet mount on the camera body slips into this scoop, thus making Programmed and Shutter-Priority Automatic Exposure modes possible. All lenses manufactured since 1982, including autofocus lenses are AIS. Autofocus lenses are distinctive enough to alleviate any question of their being AIS, but detecting AIS on non-autofocus lenses is not as clear cut.

Determining if a lens is AIS can be accomplished by examining the aperture ring. The minimum aperture number (the largest number) should be bright orange in color for both the ADR (Aperture Direct Readout) aperture numbers and the main set of aperture numbers. If only the main aperture numbers have a bright orange number, chances are it is not an AIS lens. A groove cut

The sky is the limit for the 8mm f/8 fisheye which can capture everything from horizon to horizon when pointed skyward.

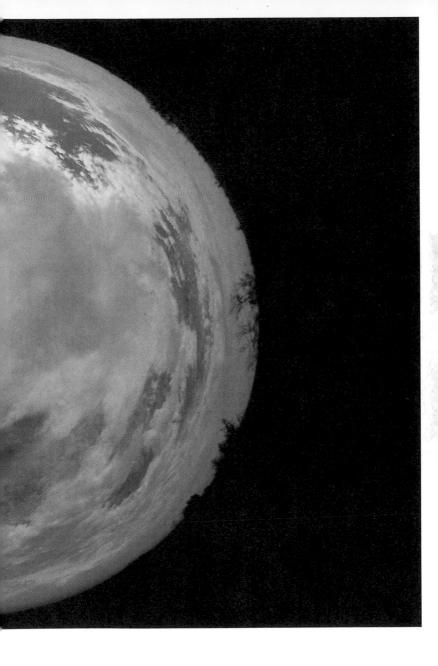

- 1. Meter coupling ridge
- 2. Protective collar
- 3. Auto aperture coupling lever
- 4. Focal length identification notch
- 5. Aperture indexing post

Nikon AI-S bayonet mount.

out of the back of the lens mounting flange alone does not necessarily mean it is AIS. Some lenses were manufactured as AIS but older aperture rings lacking the bright orange number were used. In this case, testing the lens on a body with the appropriate modes and seeing if they are activated is the only way of determining if the lens is truly AIS.

Al and Non-Al Lenses

Manual focus lenses without the bright orange minimum f/stop number are either Al or non-Al. The non-Al system is typified by the half-moon chrome tab fork attached to the top of the aperture ring. The Al lens also has the non-Al half-moon tab, but in addition has a lip on the rear surface of the aperture ring which engages with a small tab on the camera's lens mount. As these two early versions of meter coupling do not interface with all functions on current camera bodies, they are not described in this book. For a complete, detailed listing and description of every Nikon lens ever manufactured, refer to my Nikon System Handbook.

Autofocus Lenses

While most current Nikon lenses have autofocus capability (remember though that every autofocus lens manufactured by Nikon will also operate manually), a few manual lenses continue to be manufactured. These are mainly highly specialized lenses such as ultra wides and super telephotos. The construction and optical engineering of manual lenses is different from autofocus. These differences, in most cases, make autofocus the better option when choosing between the two styles of lenses.

When autofocus lenses were first introduced, their "plastic" feel was really scorned. The general feeling of photographers was that they would not take the "punishment" for which Nikkor optics were well known. This has proven to be false (hindsight is of course 20/20). The materials used in the construction of autofocus lenses actually give better overall service than those in the manual lenses they replaced. No lens works well after being dropped or wiped out by a football player crashing into it, but the "plastic" barrel of the autofocus lens is usually more forgiving of the occasional bump than the metal barrel of manual lenses. The ability to "bounce back" rather than be permanently dented, as typically happens with metal barrels, allows them to continue functioning.

The "plastic" barrel of the Nikkor lens is really a composite of a number of materials. Glass-reinforced polycarbonate best describes the outer casing of the barrel which is internally reinforced with metal where appropriate. Nikon has kept the actual list of components comprising its barrel construction a trade secret, so this is a generalized summation of the construction.

An important aspect of the "plastic" barrel is that it does not conduct electricity. With the inclusion of CPUs in lens construction, it is important that if dented, the barrel does not short out the lens' CPU. This same principle is true for camera bodies which are full of CPUs and electronics which connect the components.

The main difference that sets manual and autofocus lenses apart cannot be seen externally because it is the method in which the elements move internally. The manual lens focuses via a helicoid, an oversized nut and bolt system. This is activated by turning the focusing ring which moves the lens barrel and its attached groups of elements back and forth, thus focusing the image on the film plane. In some older lenses, focusing from infinity to the mini-

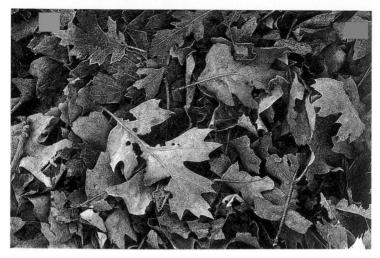

The 105 f/2.8 Micro was the perfect choice for capturing frost on fallen oak leaves in the High Sierras.

mum focusing distance requires turning the lens' focusing ring more than 360 degrees. This is very slow, providing little response to moving subjects. The helicoid is an all metal unit requiring a thin layer of special lubricant in order to function. This same lubricant was the main reason older zoom lenses were able to zoom and when a zoom got "loose," the lube had to be replaced.

Autofocus lenses use what can best be described as a rack and pinion system to move the internal elements. In the original autofocus lenses, this system is what made the "tinny" noise so disliked by photographers. The system is the same in newer models, but the noise is gone. Instead of one large helicoid, autofocus lenses have a number of gears and tracks that all rotate with the turn of the focusing ring. This in turn moves the elements riding within these tracks. In some lenses, this system allows elements or element groups to move at different rates due to a change in gear ratios (remember in manual lenses they would move as one large group). This has allowed autofocus lenses, in general, to have closer minimum focusing distances than manual lenses of the same focal length.

This system also creates a lot less drag. An autofocus motor would have a difficult time trying to focus a helicoid system with

its giant threads and stiff lubricants. The self-lubricating plastic gears and tracks of the autofocus lens, on the other hand, glide easily. This is how a small coreless motor in a camera or lens can focus a lens. This "looseness" required to make autofocus work is what repelled so many photographers at first.

This construction also makes autofocus lenses environmentally friendly. With self-lubricating plastic and other such innovations, autofocus lenses are able to work in hot and cold environments without their focusing capability becoming looser or tighter. Typically, manual lenses that were used in cold environments had to be stripped down and repacked with special lubes to prevent them from locking up in the cold. Some manual lenses even oozed "lube" when they got too hot (remember the warning not to keep equipment in the trunk of a car). Neither of these situations are a problem with autofocus lenses. Best of all, the focusing mechanism of an autofocus lenses does not tend to get "looser" with age as it often does on a manual lens.

Autofocus lenses have electronics included inside their barrels. These CPUs "talk" to the camera body, communicating a number of facts. The best example is matrix metering which can only be accomplished with lenses that have CPUs. (The 500mm f/4 P is the only exception since it is a manual-focusing lens that incorporates a CPU.) The flash technology of the N90/F90 requires the lens' CPU to provide it with distance information. Designated as "D" for distance coding, these lenses, once focused, communicate the subject's distance to the camera's computer.

AF-I Lenses

The latest technology to be incorporated in the Nikkor autofocus lens is an autofocus motor. Designated as AF-I, this technology has, so far only been incorporated into three telephoto lenses (described in detail in Chapter 5). The motor's CPU connects to the autofocus sensor in the camera body and moves the elements according to information derived from the camera's computer. The motor operates from power supplied by the camera's batteries. A very important feature of AF-I motors is that they do not require battery power to manually focus. This means they can technically function on any camera body.

Internal Focusing (IF)

The first super telephotos manufactured by Nikon were two part units, with the element group fitting into a universal focusing unit. They were physically as long as their focal length, a 600mm lens was physically 600mm long, a 1200mm lens, 1200mm long, and so on. The helicoid in these original telephotos was massive (housed in the focusing unit) with the lens barrel expanding and contracting great physical distances when the lens was focused. This was required to move the entire element group (at the end of the lens) either closer or farther away from the film plane. The turning of the focusing ring was so tremendous that focusing on a moving subject was nearly impossible. Three-inch posts were available on most versions to facilitate focusing since it was so tough.

Manual lens design radically changed and improved with the introduction of Internal Focusing (IF). Without this innovation, the development of the super telephotos used today would never have occurred.

Internal Focusing differs from helicoid focusing because only the rear element group shifts during focusing. The massive front element group never moves as in the original versions. Since this is done internally, the lens barrel does not need to expand or contract while focusing. This innovation in lens design led to the extremely compact super telephotos of today. It also resulted in benefits such as better balanced lenses, closer minimum focusing distances and lightweight construction. But probably the biggest benefit is in the speed of focusing of IF lenses. A simple and easy roll of the hand over the focusing ring is all that is required to focus an IF lens from infinity to its minimum focusing distance.

ED Optics

In conjunction with IF optical design came a breakthrough in optical manufacturing. Extra-Low Dispersion (ED) glass directly effects white light as it streaks through the lens barrel. White light is made up of many colors with their associated wavelengths,

These Mule Deer grazing on rare grasses in winter happened to wander into the view provided by my 300mm f/2.8N AF.

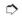

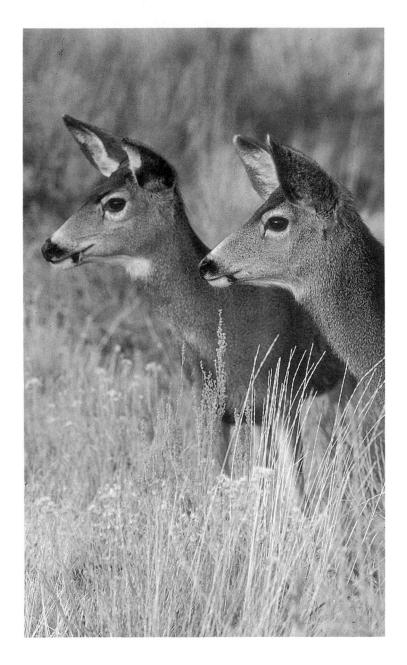

each bending differently as it passes through the elements. The blue and red bands of light (each at different ends of the spectrum, blue the fastest, red the slowest) must be brought into focus at the same point on the film plane for a photograph to be sharp. With modern technology in optical design and materials, this "chromatic aberration" is not a problem in lenses ranging from fisheye to 135mm. Beyond this focal length range though, the blue and red bands of light focus either before or after the film plane, probably causing "color fringing," or unsharp photographs.

With older, non-ED telephotos attempts to overcome this problem by closing down the aperture proved only marginally successful. Solving the problem of color fringing while shooting wide open was accomplished with the invention of ED glass (this led to the creation of the "fast" super telephotos). The actual formula for ED glass is a company secret, but what it accomplishes is not. The ED glass bends the blue and red bands of light so they focus at the same point on the film plane. This is accomplished even while shooting with the lens wide open. The introduction of ED glass also made smaller lens designs possible. And because it is not affected by heat or cold, focus shift does not occur as in earlier optics. ED glass is hard and scratch resistant which permits its use in exposed front or rear elements (though super telephotos of today have "dust proof" filters in front of these elements).

Nikon has always manufactured its own optical glass and more than 200 types of optical glass are currently being used in Nikon lens construction! Formulas for these many types of glass are created by Nikon optical engineers for manufacture in Nikon's own factories. This collection of glass is constantly expanding and improving to meet new lens requirements. The innovation of ED glass in 1975 is a perfect example of this.

Nikon Integrated Coatings (NIC)

All Nikon optics have coatings applied to their surfaces. Photography is the art of capturing light. When light passes through ordinary glass, it is reflected and diffused. If this glass were compiled into a grouping as in lens construction, this internal bouncing and absorption of light would lead to poor photographic results. Very early optical designs (before Nikon came to be) were notorious

for having problems such as ghost images, flare and most of all, poor contrast and color rendition. Many photographers, in fact, would only shoot with one lens because switching lenses would lead to different color shifts

Nikon has always been known for the faithful rendition of color in all its optics no matter what the focal length. In the 1970s, Nikon incorporated various differentiated coatings, called Nikon Integrated Coating (NIC), into its lens designs. Lens designers can apply whatever coating or combination of coatings is required, in whatever number of layers and combinations to whichever element surface necessary to perfect a lens' performance. Applied in vacuum chambers, these coatings insure the remarkable contrast, color and sharpness, that make Nikkor optics legendary! This results in quality that has become world famous as the standard by which all new lens designs are judged.

Close-Range Correction (CRC)

The designing of modern lenses is done primarily with computers. Many innovations have resulted from this marriage of the optical

This crane trying to hide under a leaf didn't fool the 60mm f/2.8 AF Micro.

engineer's imagination and the computer. Close-Range Correction (CRC) is one of those innovations that is critical to many lens designs of today. Referred to by some as the "floating element" system, CRC was developed to overcome the problem of lenses performing best only at medium focusing range to infinity.

With CRC, the elements shift their position when focused at the lens' minimum focusing distance. This element shift occurs in relation to other elements in the optical formula. Although this shift differs in various lens designs, the principle of minimizing curvature of field at close focusing distances is the same.

Correction of "curvature of field" is what many call "flat field" correction. In wide angles this means that when focused at or near their minimum focusing distance, corner-to-corner (spherical aberration), edge-to-edge sharpness on the film plane is maintained. This same CRC is employed in both the 55mm f/2.8 micro and 85mm f/1.4, providing them with the best performance of any lens in their class!

The computer has also been responsible for the design, creation and manufacture of unique elements. One such design is the aspherical element (the lens' curved surface does not conform to the shape of a sphere). The 58mm f/1.2 Noct-Nikkor is the most well known lens using this unique element. The aspherical element corrects for coma (comet-shaped blurs). For example, if photographing a subject which contains a point light source (such as a light bulb in the photograph), the aspherical element eliminates any flare caused by that light source. This same optic design is now used in the 28-80mm f/3.3-4.5 zoom, not to correct for coma, but to reduce the physical size of the lens itself.

Focal Length and Angle of View

Two of the most important terms in selecting a lens are focal length and angle of view (picture angle). These are important because they determine how the subject will be depicted in the photograph. Technically speaking, focal length is the distance from the optical center of the lens (the rear nodal point in the optical design) to the film plane (or plane of focus) when the lens is focused at infinity. But most think of focal length only in terms of millimeters, either very little or super lots.

A lens with a small focal length has a wide angle of view. These are known as ultra wides and wide angles. For example, the 13mm ultra wide angle of view is a phenomenal 118 degrees (normal human vision is approximately 45 degrees)! As focal length increases, angle of view decreases. Telephoto lenses do not magnify an image as binoculars do, but rather they capture a very narrow angle of view. For example, the 1200mm has a picture angle of just 2 degrees!

Focal length and picture angle have a great influence on the background of a photograph. The extreme angle of view of a wide angle encompasses more than the human eye can. To have any effect on the background, a camera with a wide angle would have to be moved a tremendous lateral, physical distance from the subject. The super telephoto with its extremely narrow angle of view on the other hand, would only need to move inches laterally to radically change the background. This relationship between lens focal length and angle of view to the subject and its background, is what dictates the style of a photographer. The understanding of this extremely important concept and its application is what separates the great photographers from the rest!

Definition of Terms

There are numerous generalized terms used to describe lenses. They cover their construction, disadvantages and advantages. This is important in understanding, selecting and using the right lens for your style of photography. We need to clarify these terms so when they are mentioned, everyone knows what we are referring to.

Aperture is the hole created by the metal, leaf diaphragm near or at the rear of a lens. The aperture is what controls the *amount* of light that strikes the film. The aperture can prevent vignetting and reduces lens aberrations when applied to optical designing. The size of the aperture hole is communicated in f/stops (see below). The larger the diameter of the aperture hole the lower the f/stop number (i.e.: f/2.8). The smaller the diameter, the higher the f/stop number (i.e.: f/32).

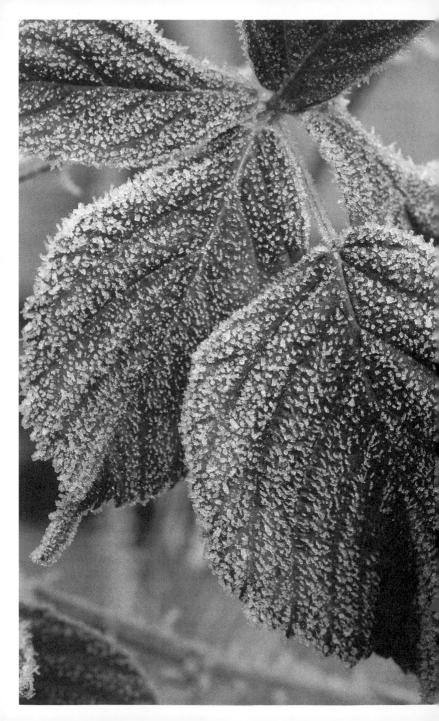

f/stop in reality is a fraction indicating the physical diameter of the aperture (though photographers do not think of it in this way). The "f" is for the focal length of the lens, the slash means "divided by" and the word "stop" is a particular f-number. For example, a 20mm f/2.8, the diameter of the lens aperture when wide open is 20mm divided by 2.8 or 7.1 millimeters. When the same lens is closed down to f/22, the diameter of the aperture hole is 0.9 millimeters. The answer to this mathematical formula is not important to everyday photography. Aperture and f/stop though technically different terms, are interchanged commonly. What is important is the understanding that they effect exposure and depth of field.

Lens Speed is a phrase based on the maximum (largest) aperture of a given lens. Lenses are considered either fast or slow. A 400mm f/2.8 is considered fast because its maximum aperture is f/2.8 where a 400mm f/5.6 is considered slow with its maximum aperture of f/5.6. The focal length is the same but the maximum aperture is two stops "slower" on the f/5.6 version. Thus, "speed" is a relative term, having no actual bearing on the final image. In general, faster lenses are physically much larger and demand a higher price, slower lenses are smaller and cost less.

Depth of Field is a zone of sharpness which falls in front of and behind the subject on which the lens is focused. Generally, depth of field falls 1/3 in front of and 2/3 behind the subject. The depth of this zone of focus is dictated by the combination of the focal length of the lens and f/stop. A general rule of thumb is the smaller the aperture (i.e.: f/32) the greater the depth of field and the larger the aperture (i.e.: f/2.8), the narrower the depth of field. When working with the 60mm micro at a magnification of 1:1 at f/32, only one inch of depth of field might be attainable, whereas using a 20mm focused at infinity at f/2.8 can capture miles. Each focal length and f/stop combination focused at various distances will have a different amount of depth of field. However, closing down an aperture to its largest f/stop number (i.e.: f/32) will not automatically guarantee the sharpest image because of a condition known as diffraction.

Piles of fall leaves tinged with frost are a treasure store of photographs waiting to be taken with the 60mm f/2.8 Micro.

Diffraction is the result of light bouncing off the narrow edges of the aperture diaphragm. The extremely small hole created by a lens being closed down completely (i.e.: f/32), restricts the light passing through the aperture that is to be focused on the film plane. The light bouncing off the edges of this small hole is diffracted and scattered at the film plane resulting in an unsharp photograph, a form of color fringing.

Lens Aberration describes the minute optical flaws inherent in most lenses. These can be in the form of chromatic aberration, spherical aberration, curvature of field or distortion.

Distortion is caused by a lens aberration which does not effect image sharpness but rather alters the physical shape of objects. Distortion can best be thought of as curving a line that in reality is straight. Most distortions are classed into two general types, "Barrel" and "Pincushion." Barrel distortion means straight lines are bowed out to the edges of the picture frame. This is most often known to occur with wide angle lenses and wide angle zooms. Its effects are best seen when using a fisheye lens. Pincushion distortion is just the opposite of barrel distortion, the lines bow in towards the center of the frame.

Contrast is the visual difference in brilliance or brightness between different elements in a scene. These differences are described as highlights and shadows and the difference in properly exposing for these determines the range of contrast in the scene. These are also described as tonal values. Lens coatings have greatly increased the amount of contrast transmitted by modern lens designs, demanding that photographers have greater skill in exposing film.

Flare is an overall decrease in image contrast and color due to light bouncing off, rather than being transmitted through a lens' surface. This was a common problem in very early optics as light would bounce off various internal element surfaces while passing through the lens barrel to the film plane. Multi-coating prevents this from occurring in modern optics except when light strikes or skims across the front lens element causing textbook flare. A lens shade can eliminate this problem.

Ghost Images are the green, purple or violet UFOs (Unidentified Flare Origins) caused by a point light source in a scene. These are most common with wide angle lenses and take the shape of the lens aperture. Ghost images were more common in older optics before advanced multi-coatings were applied to modern lens design.

Sharpness is used to describe the ability of a lens to render the fine detail of an object clearly at the film plane. This is dependent on a number of factors: contrast, f/stop and resolution being the most dominant.

Resolution is a term describing the resolving power of a lens and/or film (the two are not related). This is the ability of a lens to discern small minute detail, described in the number of lines per millimeter that can be read from a special, standardized chart. For accurate measurement of a lens' resolution, the film must have greater resolving power than the lens; this is generally the case.

Reproduction Ratio is a term indicating the magnification of a subject in macro photography. This is determined by the size of the subject photographed on the film divided by its actual size. For example, if the subject in real life is 1 inch long and it measures physically one inch long on the negative or slide, the reproduction ratio is described as 1:1 or "life size." If the same one inch subject is only one-half inch long on the film, then the reproduction ratio is 1:2 or one-half life size.

Macro is a term used in close-up photography describing a reproduction ratio up to 1:1. This reproduction ratio can be reached by a macro lens being focused to its minimum focusing distance or by the addition of extension tubes moving the lens away from the film plane. Nikkor optics fit this definition, but they refer to their lenses as "micro."

Micro is a term used in close-up photography describing a reproduction ratio greater than 1:1. This reproduction ratio is achieved by the use of extension tubes, bellows or a microscope.

Photomicrography is the process of photographing minute objects with the aid of a microscope. This generally is in the realm of 10:1 to 50:1 or greater.

Aperture Lock is featured on all current Nikon lenses, allowing photographers to lock the aperture in place at its smallest f/stop value. This is a convenience for those who shoot in Program Mode. In this mode, the aperture must be set at the smallest f/stop or the camera will not function. The lock prevents accidentally knocking the aperture from this position.

Free Working Distance is a term related to close-up photography which describes the distance between the subject and the front of the lens. This distance increases as the focal length of the lens increases and can be a very important consideration in the purchase of a "micro" lens.

Caring for your Nikon Lens

Caring for your Nikkor lens is important in maintaining a long life of service. Care takes very little time or energy and insures consistent quality and performance. Equipment should be cleaned after each use, whether this was for just a moment or all day. This includes camera bodies as well as lenses.

Clean the front element as infrequently as possible. When the front or rear element does need cleaning, first blow off the element to remove any large particles which could scratch the element. Small bulb blowers or canned air can be used. Note that with the introduction of the first ED lenses, Nikon advised not to use canned air as its cold blast could cause damage. This was in the 1970s and before dust proof permanent front elements were used on ED lenses.

Lens tissue is the most commonly used material for wiping off a front element. Normally when an element needs cleaning, it is because something has spotted the glass. In this case a fluid is quite often used to remove the spot. Fogging the glass with one's breath is an excellent, nonabrasive way to clean an element. If a fluid cleaner is used, be sure to apply it to the lens tissue and not directly to the element. The reason is the drop can flow down the element and into the lens mechanisms or other internal elements.

Cleaning the lens barrel is as important as cleaning the elements. The oil from our palms and the dust that sticks to it on a lens barrel can work its way into the lens. Use a cotton t-shirt to simply wipe down the outside lens barrel after every use. This will prevent any grit from getting into the workings of the lens and causing expensive repair bills.

To get the most out of this book, it should be read from cover to cover. Though some techniques are repeated (for those who only read about particular lenses), many are mentioned only once with a particular lens. This, by no means implies that the technique is valid with only the one lens, but was only mentioned once to keep the book from being hundreds of pages. Techniques from one lens can be applied to others and by reading the entire book, all of these techniques will come to light. Only with the knowledge of all of these techniques can every lens in your camera bag be an essential part of your photographic bag of confidence.

Fisheyes and Ultra Wides

Tricks of the Trade

Lenses are designed with a specific purpose, to solve particular problems faced by photographers in capturing an image on film. The fisheye and ultra wide lenses are no exception to this rule. What is the purpose of the fisheye, a lens that takes circular photographs?

Since the conception of fisheye lenses in 1963, their unique perspective on life has been put to very practical applications. In the 60s, construction of massive boilers in power plants and thousands of miles of pipelines was taking place. The assembly, welding and layout of these cylindrical units required the fisheye lens to document the work in progress. Its ability to cover the entire area of a boiler or pipe in just one photograph, made it indispensable in quality control and tests. Meteorologists and astronomers also found the fisheye of tremendous use in their work. Some fisheyes such as the Nikkor 10op were made specifically for them.

The physical size and cost of the 6mm fisheye puts it out of range for most photographers. The 8mm, though, can be easily handheld and is priced where those who want to explore their world through its curved perspective can. The 16mm which is a full frame fisheye has always been popular and resides in many camera bags for those special times when only a fisheye will do the job.

The tremendous angle of view and barrel distortion of fisheyes can make some dizzy when viewing through them. Photographs taken by them are best known by the curved horizon line. The horizon line will be either curved up giving the illusion of a round planet or curved down making it look like you are standing in a giant crater. But if the horizon line is placed directly through the center of the frame, the horizon will not bend at all, only the vertical subjects will be curved by the barrel distortion.

Watch Out for Strays!

Some things to be aware of when using fisheyes are toes and tripod legs. Because their wide angle of view takes in so much, severely tilting the lens up is necessary to exclude feet and toes when shooting handheld. And with most normal tripods, one if not two tripod legs will appear in the photograph. This can be remedied by using a tripod such as a *Benbo®* from Saunders

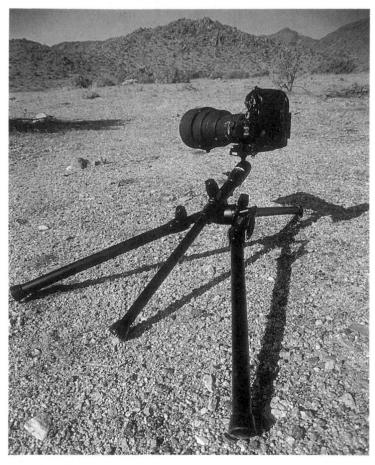

No other tripod in the world can perform the contortions that a Benbo can! It is the most versatile tripod I have ever used.

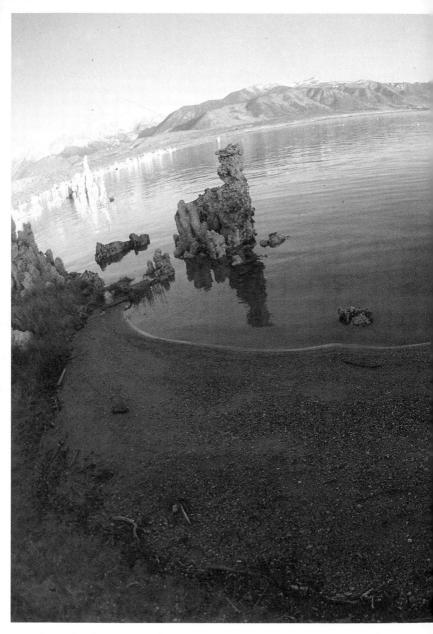

Capturing the expanse of Mono Lake and emphasizing its vastness is best done by curving the earth with the $16\,\mathrm{mm}$ f/2.8.

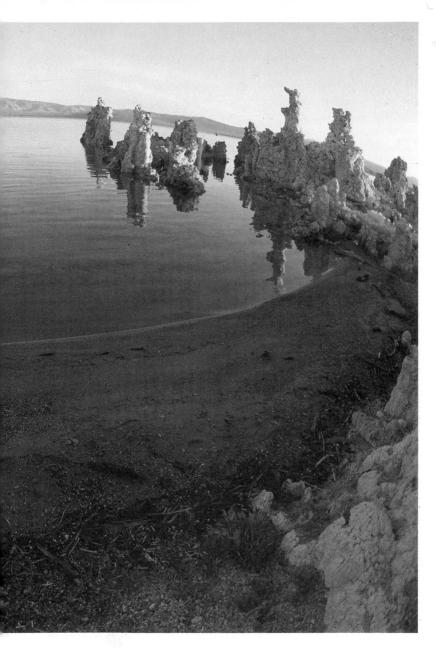

which allows the individual positioning of the legs and center column.

When they get their photos back, many photographers see funny brown and black lines near the edges of their photograph. This is not an optical flaw in the lens, but rather the fingers and camera strap holding the camera in use. Because so much is crammed into the frame, everything is smaller and harder to see through the viewfinder. One must be very careful when using a fisheye so that a branch which is physically behind the lens does not end up in the photograph, especially with the 6mm.

Vignetting

The tremendous coverage of these lenses nearly precludes the use of front element filtration. Vignetting is a common problem (caused when the mount of the filter cuts into the frame). Checking for vignetting requires using a camera with 100% viewing. With the lens attached to the camera, close the lens down to its smallest aperture and depress the depth of field preview button. The corners will not darken. This should hold true when a filter is attached. This same test can be performed to check for vignetting with stacked filters, an attached shade or when using a hand as a shade.

Making the Subject Pop

If there is a trick of the trade in using ultra wides, it is eliminating the junk in the photograph. Most pigeon hole the ultra wides to scenic duties which they capture like no other lens, but their real gift is their tremendous depth of field and their ability to relate elements in a photograph. The best photographs are ones where the subject pops, not getting lost in the tremendous coverage of the ultra wide.

Real talent and skill are required when using ultra wides. Physically moving, whether laterally, up or down, closer or farther from the subject, is the only method of eliminating unwanted objects from the photograph. First seeing and recognizing these unwanted elements and then getting them out of the photograph are not easy jobs considering you are working with 118 or 110 degrees of coverage. Probably more than any other focal length, a fisheyes' and ultra wides' view of our world demands a photographer's undivided scrutiny for success. They also require

a vast amount of imagination in finding subjects, then in finding solutions to make the subject pop.

All of these lenses focus extremely close. My first exposure to the 6mm lens was a photograph of a grasshopper which was resting on the front element of the lens with the entire world behind it in focus! Getting physically close to the subject is probably the best way to eliminate unwanted clutter. Since these lenses can focus close and have a huge depth of field, make use of it to be most effective in communicating the grandeur that is being captured!

Nikkor 6mm f/2.8

Original release: 1969 Filter size: 5 built-in filters

Angle of coverage: 220° Lens hood: none

Unique features: image diameter

23mm

Physical size: 9.3"x6.7" **M.F.D.:** 0.9'

Weight: 183.7 oz. Aperture range: f/2.8-f/22

The front element of this lens is 235 millimeters across! It comes with a special leather cap that snaps onto the rear of the front element housing and its lens case is a wooden trunk! Its tripod mount is the same size and design as those found on telephoto lenses. If this does not give you the impression that this lens is huge, maybe the fact that it weighs over eleven pounds will!

The design of this lens has not changed since it first was released, other than its aperture ring being updated to AIS coupling. This lens can literally "see" behind itself with its 220 degrees of coverage. Because of this, the 6mm has a cantilevered lens stand which prevents it from being in the photograph. Unlike a typical tripod collar, this one slants back out of the view of the lens.

The lens' angle of view coupled with its large front element, prohibits the use of any filters over the front element. To provide some filtration, five filters are built into the lens in a turret: the L1a, Y48, Y52, O56 and R60. The L1a is the only filter out of that selection that is usable with color films. Many photographers who own the 6mm have had the stock factory filters removed and custom ones installed for special applications.

This large front element and huge coverage also makes using a lens shade impossible. The back-up shades we always have with us, our hands, are also not usable. Cable releases, hands, tripods and your camera's neckstrap can easily be in the photograph as well. Avoiding all of these obstacles is a *must* to create a successful photograph with this marvelous lens.

When shooting with this lens, the sun will almost always be in the photograph unless an element in the scene such as a tree

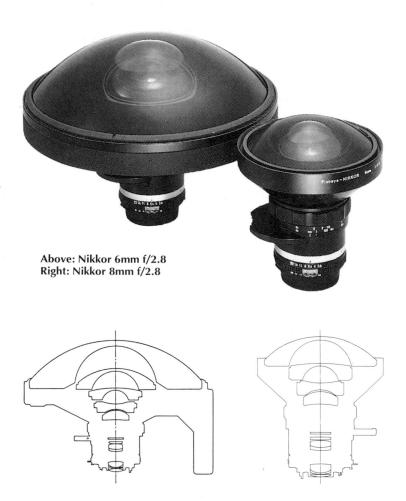

limb is blocking it. Because of this, the front element must always be kept clean. Any dirt or moisture rings on the front element will show up in the photograph as a very bizarre type of flare. So cleaning the front element properly and keeping it clean is very important.

Because of the physical size and weight of the 6mm, a heavy duty tripod and head must be used. This is particularly true because of the contortions that must be used to eliminate unwanted elements, especially feet and tripod legs. The lens is quite often tilted up to take in less ground. On a standard tripod and head, it would flip over and send itself crashing to the ground. The *Benbo 2XL* tripod is a natural for this special application lens because it can be set up in ways dictated by the lens' coverage.

Those looking to buy this lens, take note that a new lens can be acquired by special order only. Nikon does not stock this lens. There are a number of lens rental houses across the country that do stock and rent the 6mm. This is the most common way photographers obtain this lens for use.

Nikkor 8mm f/2.8

Original release: 1970 Filter size: 5 built-in filters

Angle of coverage: 180° **Lens hood**: none

Unique features: image diameter

23mm

Physical size: 4.8"x5.5" **M.F.D.:** 1'

Weight: 38.9 oz. Aperture range: f/2.8-f/22

The 8mm is the most practical of the circular image fisheyes to use. The original 7.5mm, 8mm and 10mm lenses required the camera's mirror to be locked up, making SLR viewing impossible. They were handholdable though because of their small, compact design. The 6mm advanced fisheye lens is SLR viewable, but it is far from handholdable. The current 8mm is the only SLR viewable, handholdable fisheye Nikon has produced, which accounts for its popularity.

Everything, repeat *everything* in front of this lens will be in the photograph! The 8mm barrel is physically long enough to permit handholding while excluding ones fingers from being in the

photograph. The 8mm has a smaller angle of view than the 6mm, but its 180 degrees still takes in enough to require watching out for ones toes. Tilting the lens up is the best option for eliminating toes and tripod legs. Using a tripod can still be difficult with the 8mm, requiring the unique features available with *Benbo* tripods, mentioned above.

The 8mm has 5 built-in filters: the L1a, Y48, Y52, O56 and R60. It has an equidistant projection formula which means that the optics of the lens create no hot spots or vignetting. The exposure is even over the entire 180 degrees. This is important as a blue sky would otherwise look very unnatural; light blue on one side of the frame and dark blue on the other because of the near total horizon coverage of the 180 degrees. If a polarizer were used (though not possible) with the 8mm, the equidistant projection formula would render the scene with uneven exposure since the polarization effect over 180 degrees would not be even.

In Nikon's literature, uses for the 8mm include science and industry. It also includes portraiture which might strike photographers as odd. Automatically one might think this would turn a subject into Mickey Mouse or Pinocchio. If the subject is centered in the frame, the nose being the dividing line both vertically and horizontally, and subject is not a great distance from the lens, the subject will be recognizable. If one wants to have fun though, put the subject off center or away from the lens and watch that nose grow!

The 8mm is great for taking scenic shots! If the scene contains any lines, such as roads or paths, the tremendous depth-of-focus of the lens and its barrel distortion will give the photograph incredible visual depth. Depicting such subjects as tree canopies is fun with the 8mm as it will capture the tree trunk along with the canopy. As with any wide angle though, success comes from eliminating the junk. Using a camera that provides 100% viewing and looking carefully at all that is in a scene can make shooting with a fisheye very fun and tremendously rewarding!

The front element must always be kept clean on the 8mm. Because the sun will almost always be in the photograph, any dirt or moisture rings on the front element will show up as a very bizarre type of flare. So cleaning the front element properly and keeping it clean is very important.

Nikkor 13mm f/5.6

Original release: 1976 Filter size: 39mm bayonet

Angle of coverage: 118° Lens hood: built-in

Unique features: rectilinear, CRC

Physical size: 4.5"x3.9" **M.F.D.:** 12"

Weight: 42.4 oz. Aperture range: f/5.6 - f/22

The 13mm f/5.6 is the widest lens in the Nikon line (excluding fisheyes). Along with the 15mm, it shares a common design feature, rectilinear correction. This is a fancy word for straight line rendition. Where a fisheye of this coverage "bends" straight lines making them curve, rectilinear design corrects for this barrel distortion. This design element makes the 13mm physically quite large, almost to the point of excluding it from being handheld.

The tremendous coverage and large front element (approximately 110mm) prohibits the use of front filters or accessory lens shades. Filters bayonet on at the rear element, with Nikon providing four (A2, L1B, O56, B2) with the lens (hidden in the lid of lens case). It is impossible without great expense to polarize or use a graduated neutral density filter on the 13mm (they must be custom made). The most common way to use other filters on the 13mm is by using gels taped to the rear element. This is the only way of employing a polarizing filter. It is a slow method as the filter must be moved every time the direction in which the lens is pointed changes. Even then, the tremendous coverage of the lens might create uneven exposure because the polarization effect would not be the same across the entire 118 degree field.

Probably a bigger problem with this ultra wide is the shade. The built-in, scalloped shade provides minimum coverage at best. Because of the lens' wide angle of view, a more adequate built-in shade would vignette into the frame. The extreme angle of coverage also produces tremendous flare problems if one is not careful. These flares materialize in the form of purple or dark green "UFOs" (Unidentified Flare Origins). They normally show up in the bottom of the viewfinder and they can occur even when the sun is not in the picture. Using a hand or small piece of cardboard as an auxiliary shade is the only option for ridding the photograph of this flare. Care must be taken when doing this, as

the auxiliary shade can cause vignetting. This is a very good reason to use this lens on a camera with 100% viewing.

The front element must always be kept clean on the 13mm. Because the sun will quite often be in the photograph, any dirt or moisture rings on the front element will show up as a very bizarre type of flare. So cleaning the front element properly and keeping it clean is very important to getting a clean image.

With the 13mm's incredible angle-of-view and ability to focus so close, it is used most often to relate the subject to the background rather than just taking scenic shots. Getting close physically to the main subject, making it the largest element in the photograph and then letting the tremendous depth of field of the 13mm bring in the background is one of the main applications of this lens. Many cover photographs are taken with this lens used in just this way.

To take advantage of this technique, handholding is usually required. Because the focusing ring is very narrow and at the end of the barrel, proper handholding technique, described on page 49, must be followed. Special care must be taken that a dangling finger does not get in the photograph when handholding.

Because of its price and scarcity, the 13mm is rarely available for purchase. It is commonly stocked at many lens rental houses which is the best way to experience this magnificent lens for one-self.

Nikkor 15mm f/3.5

Original release: 1980 Filter size: 39mm bayonet

Angle of coverage: 110° **Lens hood**: built-in

Unique features: rectilinear, CRC

Physical size: 3.5"x3.7" **M.F.D.:** 1'

Weight: 22.3 oz. Aperture range: f/3.5-f/22

The 15mm f/3.5 could be considered the baby brother of the 13mm f/3.5. It is physically smaller than the 13mm, making it easier to use and is also less expensive, making it easier to find in stores. Of all the ultra wides, the 15mm is probably the most commonly owned because of its spectacular angle of view and comparatively modest price.

Like the 13mm, the 15mm flares with little provocation. The source of the flare can be a point-light source or bright sun streaming through the canopy of trees. It can also be a reflection off a body of water or from a side window in a room. The flare is typically a dark purple aberration in the lower edge of the photograph, a color that is rarely hidden by the colors found in the scene itself.

The best way to rid the photograph of flare is by simply blocking the light source creating it. The 15mm has a built-in scalloped lens hood, but it is not enough for many situations. Typically, using one hand to block the cause of the flare works great, but this does hinder using the lens handheld. Many use hinged arms to position a small, curved piece of cardboard to shade the lens. This requires a tripod though, but one photographer I know did hook up a small arm to the base of his camera to act as an auxiliary shade, permitting it to be handheld.

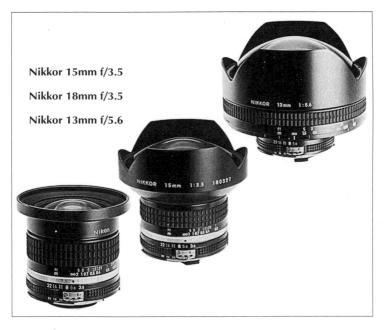

Finding natural elements in the photograph to block the flare problem is probably the best option. This takes talent when also trying to compose a photograph. The other option is to physically move laterally the slight distance required to eliminate the flare from the view of the lens. These options, either singly or in combination will usually solve the problem. However, making the most of them takes practice.

The 15mm comes with four rear bayonet filters (hidden in the lid of the case) one being an A2 (81a). Filtration such as polarization is very difficult. Many use large gels held in front of the lens to polarize a scene. Others use them taped to the rear of the lens, but neither are easy solutions. Graduated filters can be used in the front with a little more ease. Using the large, 5"x5" filters in front of the element can work, but great care must be used to avoid flare. Any of these filters placed in front of the lens can catch light, causing flare that limits color and contrast. They might also vignette if care is not taken.

Working with the 15mm is an incredible experience. Many of the great photographs taken with this lens were taken at every angle but eye level. Getting down low and pointing up or getting up high and pointing down are the most widely used techniques with this lens. Because of the rectilinear design, this change of angle only heightens the depth in the photograph and not the lines. Because the 15mm can focus so close and has such tremendous depth of field, these techniques can be explored to their fullest while rendering everything tack sharp.

Like many rare lenses, the 15mm can be rented at lens rental houses. Because of its popularity, it is also stocked new by many stores. Before buying a 15mm, rent one to see if its wide coverage suits your style of photography. Make sure that all the "hoops" you must jump through to get the perfect photograph fit the way you like to take pictures, as well.

This photo of the giant coastal redwoods was shot with the 20mm f/2.8 AF to accentuate their towering majesty as well as add depth to the forest.

Nikkor 16mm f/2.8

Original release: 1979 Filter size: 39mm bayonet

Angle of coverage: 180° Lens hood: built-in

Unique features: full frame fisheye

Physical size: 2.5"x2.6" **M.F.D.:** 1'

Weight: 11.7 oz. Aperture range: f/2.8-f/22

The 16mm is a chameleon. More than any other lens in photography, changing the technique in which the 16mm is used can radically change its affect on a scene.

Its full-frame, fisheye image encompassing 180 degrees is its secret to being such a chameleon. The 180 degrees is across the diagonal of the 24mm x 35mm film format. This produces its extreme barrel (fisheye) distortion as well as its virtually unlimited, exaggerated perspective. Remember this is being stretched, if you will, over the full frame rather than producing a circular image. It is being done while providing even exposure over the entire frame. The 16mm is extremely well-corrected for chromatic aberration, producing slightly higher contrast images which are assured, even when shooting wide open.

The 16mm has a built-in, scalloped lens hood which seems to be more than adequate. Even with its greater coverage than the 13mm or 15mm, it tends to have less flare problems. This is partially because its front element is physically smaller in diameter than the 13mm or 15mm. It still flares, but not as easily which is good, as curing flare with the 16mm is nearly impossible with its 180 degree coverage. Any hand or auxiliary shade is instantly in the photograph no matter how much care is taken to avoid that situation.

The "trick" to using the 16mm is in understanding when and where to apply it. The barrel distortion is at its greatest when the lens is pointed either up or down (that is if standing on a flat surface and shooting horizontally). When the horizon line is running through the dead center of the frame, this distortion is nil, affecting only vertical elements at the extreme edges of the frame. If there are no straight vertical lines in the photograph that the viewer can use as visual guides, the affect of the fisheye is negligible. Being above the scene, either on a cliff, ladder or the like,

masks the effect of the fisheye as long as the horizon line is running dead center through the frame.

This technique makes the 16mm great for photographing such subjects as scenic shots. This also opens up possibilities in other realms in photography. For example, the 16mm is one of the most popular lenses to use for remotely taking flight shots. Attaching a remote camera on the end of a plane or hang glider wing captures dramatic images. Because the wing is so long, any distortion of its lines is not noticeable. The added benefit is the earth in the background will have a slight curvature to it and as the earth is round, this is accepted as being an accurate rendition. No one will think the photograph was taken with a fisheye.

If the lens is used in a vertical format, or any of the parameters above are not followed, the full-curve whammy of the lens comes out. The 16mm is a chameleon that can change as easily as ones imagination. Whether using it to capture breath-taking scenic shots or making ones tongue look miles long, its 180 degree view is really quite limitless.

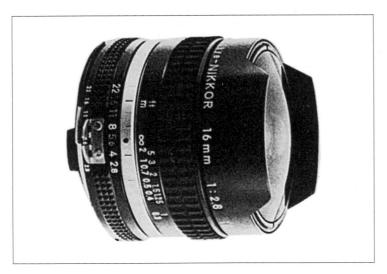

Nikkor 16mm f/2.8

Nikkor 16mm f/2.8D AF

Original release: 1993 Filter size: 39mm bayonet

Angle of coverage: 180° Lens hood: built-in

Unique features: full frame fisheye

Physical size: 2.5"x2.2" **M.F.D.**: 0.85'

Weight: 11.5 oz. Aperture range: f/2.8-f/22

The 16mm f/2.8 AF is basically just an updated 16mm f/2.8. All techniques mentioned above would apply in getting the most out of this lens. One advantage this lens has over the manual version is the technique that can be applied to it because it has autofocus technology.

Since the camera can focus the 16mm f/2.8 AF without the eye of the photographer, remote photography with it gives the chameleon one more way to change colors. For a lens that can be in focus at any point at infinity, autofocus will come into play when using it close to the subject. Holding it above a crowd and shooting down, holding up it on a pole to photograph the side of a building or down a canyon wall, the AF will allow close focusing while still capturing the stunning 180 degree view.

In the years to come, magnificent photographs will come from this lens as those with imagination and creativity greater than 180 degrees put it to use. This will bring the popularity of the 16mm and its effect back into the limelight as new and creative uses are found for its unique perspective.

Filtration on the 16mm AF is the same as the manual version, the 13mm and 15mm: 39mm bayonet filters attached to the rear element. A variety of filters can be used with rear bayonet filtration by simply taping gels to the rear element. Polarization can even be accomplished in this way though it is difficult. Using color correcting filters in this way is most common. Just remember to keep the gel small enough not to interfere with any camera/lens interfacing.

Nikkor 18mm f/3.5

Original release: 1982

Angle of coverage: 100°

Unique features: CRC

Physical size: 3"x2.9"

Weight: 12.4 oz.

Filter size: 72mm

Lens hood: HK-9

M.F.D.: 0.85'

Aperture range: f/3.5-f/22

An amazing lens, the 18mm has to be one of the least known of Nikon's ultra wides. There are a number of reasons for this, mostly its price versus its coverage compared to the 20mm; this has caused it to be left, all too often, on the store shelf. Even so, it is commonly stocked by camera stores and often found in the Domke® bags of photojournalists.

Those who use the 18mm are true artists and technicians who know the secret to making the 18mm work. It has all the benefits of the 13mm and 15mm: wide coverage, close focusing and basic straight line rendition. Applying the techniques of these ultra wides to the 18mm is the secret of success. It is often used by photojournalists held overhead to photograph into a crowd. Since it does not distort, it is a natural in this application. This makes it a top choice for getting close to a subject and relating it to its background as well, another common photojournalists' technique used by many.

It has the big bonus over the 13mm and 15mm of accepting filtration. It accepts 72mm filters which are common, coming in many "flavors" to fit almost any situation. But filtration is limited to just one, as stacking of filters is not possible because of vignetting (the second filter cuts into the photograph). This means warming up the scene and polarizing it can be impossible. Or is it?

Attaching a gel to the rear element, such as an 81a, frees up the front filter threads for a polarizer or graduated neutral density filter. Care must be taken to avoid scratching the rear gel filter both when mounting the lens on the camera or when storing it in the camera bag. Scratching it up when attaching the rear lens cap won't help it either.

The 18mm's ability to be filtered while having the benefits of an ultra wide, makes it a natural for scenic photographers. The 18mm has the added quality of not flaring like the 13mm and 15mm. With all these attributes, it is not hard to understand why those who own and shoot with 18mm f/3.5's swear by them!

Nikkor 20mm f/2.8 AF

Original release: 1989 Filter size: 62mm Angle of coverage: 94° Lens hood: HB-4

Unique features: CRC
Physical size: 2.6"x2.1"

M.F.D.: 0.85'

Weight: 9.2 oz. Aperture range: f/2.8-f/22

The 20mm AF is probably responsible for getting more photographers into ultra wides than any other lens. Though slightly larger than its predecessors, the f/2.8 version has even caught more photographers' attention. Its extremely compact size, reasonable price and wide angle of view make it a great choice for nature photographers.

The 20mm combines all of the benefits of the 13mm, 15mm and 18mm with the added advantage of more filtration options. Filter systems such as *Cokin®* can be used with the 20mm without vignetting. *Tiffen's®* 2 stop graduated filter which is in a rotating mount can also be used on the 20mm, thus, compacting the exposure latitude down within the range of today's film. The 20mm will not work with two stacked filters, so attaching one at the rear element might be required. The exception to this is using Nikon's A2 with the 62mm polarizer. Since Nikon's 62mm polarizer has a built-in step-up ring, vignetting is negligible in the corners.

Of all the ultra wides, an application only possible with the 20mm is close-up photography. The most common use is reversing the 20mm. The Nikon adapter BR-5 is required, screwing into the 62mm filter thread of the 20mm. It can then bayonet onto a camera body or more commonly, onto a bellows unit. On a camera body, this set up provides 3x magnification and on the Nikon PB-6 bellows, a maximum of 10x magnification is possible. Focusing is accomplished by moving the camera/lens physically closer or farther from the subject. Both meter and automatic aperture coupling are lost when a lens is reversed.

The majestic sand dunes of Death Valley were frozen in time by the 35-70mm f/2.8 AF.

Even without reversing, the 20mm is great close-up. It can focus down to 0.85 feet and since it has CRC, its image quality is magnificent. If there is a trick in using this lens, it is in applying it to situations other than scenic shots. Many stunning photographs taken at close range with the 20mm have left photographers viewing the image, puzzled as to how it was done. That's why the 20mm is so popular, it can capture ones imagination!

Wide Angle and Normal Lenses

Tricks of the Trade

The lenses in this range are the most familiar to photographers. For two decades the "normal" or 50mm lens was the most common lens as it came with every camera body ever sold. Since the 50mm has the same angle of view as our vision, it became known as the "normal". It also became the most discarded.

The wide angles in this range are the widest most photographers ever explore. There are two reason for this. One is they are the widest lenses most stores stock. The second reason relates to the first, the wide angle view does not look attractive enough in the confines of a store showroom to sell the lens well. The best salesperson for wide angles are the captions in photo magazines saying that the shot was captured with a particular wide angle.

The tricks of the trade to wide angles are in the way they are pointed. Most photographers walk up to a scene and go click right at eye level. This is the least effective way to use a wide angle. Getting up close physically to the subject, then angling the lens down to sweep over the scene is much more effective and a common technique of the pros. This technique can be used whether shooting a macro scene or grand vista. It isolates the subject while relating it to its background. This takes advantage of the inherently large depth of field and grand angle of view of the wide angle.

As with ultra wides, eliminating unwanted elements is critical. This is easier with wide angles as their angle of view is not as great as ultra wides. With ultra wides, every millimeter of frame must be checked for junk. With wide angles, unwanted elements are found in just one area or another in the frame. This lends speed to using wide angles in that less "technical" time is required in using them. Using a camera with 100% view still is an asset with wide angles. If that is not the case, then careful examination is required to make sure unwanted elements are not inadvertently being captured.

Getting more out of the wide angle is a common quest. Many want to achieve the grandeur of the ultra wide with their wide angle. This can be visually accomplished by using elements to create depth in the photograph. Including lines such as roads, trails, fallen logs, a coastline, or any element that starts in the foreground and continues to the horizon, adds to the feeling of depth. This creates the illusion of an ultra wide in a wide angle view. Getting low and having large elements in the foreground on one side of dead center can create the same illusion. The trick in either case is creating and depicting depth in the photograph. This is something that can be accomplished by lighting as well but that is a book in itself.

The slam on normal lenses has always been they do not capture any pizzazz. They are not supposed to! And here lies the trick to using them. If a survey was to be conducted of all the "great" photographers, it would be found that they started with a normal lens and from them, exploration into creativity was launched. The "non-pizzazz" factor of the normal is a push towards exploring other realms in photography.

These explorations are the basis for techniques later applied to wide angles and telephotos. These same techniques are often applied, by those who have yet to add to their lens collection, to the normal to stretch its potential. More than any other focal length, the 50mm can be manipulated with auxiliary accessories to accomplish other tasks. Teleconverters, extension tubes and reversing rings are just a few of the auxiliary accessories that can be added to this focal length to start exploring other facets of photography.

Proper Handholding Technique

All of the lenses in this chapter lend themselves to being shot handheld. This requires using proper handholding technique to capture all the sharpness the lens can deliver. Handholding first requires having the lens rest in the palm of the left hand. Grabbing the lens in any other fashion will force you to fight gravity which will always be trying to pull the lens from your hands. The focusing and aperture ring are then both operated by the left fingers. The right hand operates the camera and should grab it so the index finger can reach the shutter release. Next, press the camera body up against the forehead. A rubber eyecup helps by acting as a shock absorber. Then, tuck the elbows in against the stomach. This creates three points of contact like the three legs of a tripod.

A sunset portrait of the century-old Main Street of Bodie State Park.

Nikkor 24mm f/2

Original release: 1978 Filter size: 52mm Angle of coverage: 84° Lens hood: HK-2

Unique features: CRC Physical size: 2.5"x 2.5"

Weight: 10.6 oz. Aperture range: f/2-f/22

M.F.D.: 1'

For the typical photographer, this is one of the more esoteric wide angles. The 24mm f/2 has a bright image, aiding focusing in low light levels, and its fast f/stop aids in shooting in available light as well. For these reasons, the 24 f/2, since its introduction, has been very popular with photojournalists. However, its price and slightly larger size, prevent most photographers from investing in its speedy optics.

One of the amazing attributes of the 24 f/2 is its ability to limit depth of field. The inherent tendency of wide angles to have everything in focus can be a drawback at times, especially if that is your style of photography. The f/2 aperture narrows the depth of field enough to make a difference when compared to f/2.8.

Getting physically close is a preferred method of using the 24mm f/2. This limits the depth of field even more, isolating the subject from the background. Photojournalists often do this so the subject is sharp, but other elements in the photograph are recognizable but not sharp. This makes the subject pop while still relating it to the background. This technique is rarely seen in scenic shots simply because so few own this lens.

With the growing interest and use of CD ROM technology in photography, the 24mm f/2 might see a increase in popularity. Those shooting specifically for this format prefer the faster, brighter image of this fast f/stop. The slightly higher contrast of the 24mm f/2 is another reason why it is popular for this application.

Nikkor 24mm f/2.8N AF

Original release: 1991 Filter size: 52mm Angle of coverage: 84° Lens hood: HN-1

Unique features: CRC

Physical size: 2.5" x 1.8" **M.F.D.:** 1'

Weight: 8.9 oz. Aperture range: f/2.8-f/22

Since its original introduction the 24mm f/2.8 has been extremely popular. It has gone through more cosmetic and optical changes than any other Nikkor lens with the 24mm f/2.8N AF being the best version to date. Its small size, both physically (and monetarily) has made it one of the most popularly owned wide angles.

The 24mm lens is credited with more scenic shots than any other lens. Twice as wide as normal vision, it has a very comfortable feel to its angle of view. It does not have the "distortion" that many photographers associate with wide angles which also adds to its appeal. Because of this, its wide coverage is "comfortable" and not beyond the realm or imagination of most amateur photographers.

Even with all its popularity, the 24 f/2.8 is probably one of the most misunderstood wide angles. Its comfortable feel is partly to blame for photographers not exploring its angle of coverage to the fullest. All of the techniques discussed in the previous chapter can be applied to the 24mm f/2.8 to really make it sing. This includes reversing it for close-up work since the lens' CRC delivers incredible edge-to-edge sharpness. This also includes getting close physically and angling the lens down so its coverage sweeps over a scene or getting down low and sweeping up for dramatic rendering of moody skies.

The autofocus 24mm f/2.8 has a limited depth of field scale on the barrel of the lens. When using the lens and applying the Hyperfocal Distance principle for example, this scale can be hard to use. Many photographers conduct their own depth of field tests and create their own depth of field scale to use with the lens. This scale can be attached to the lens via a stick-on label or by writing the information on a card that is held up to the lens barrel when using the technique. This is an excellent idea when striving for the same results every time this technique is used.

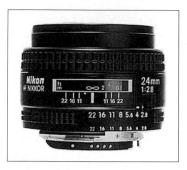

Nikkor 24mm f/2.8N AF

The 24mm f/2.8 is still wide enough that filtration can be a challenge. Using Nikon's polarizer helps as it has a built-in step-up ring. This makes the stacking of filters possible. Off-brand polarizers can be used, but not stacked with other filters. Testing by using a camera with 100% viewing is recommended when using stacked filters if there is a question of vignetting

Nikkor 28mm f/1.4D AF

Original release: 1993 Angle of coverage: 74°

Unique features: fast lens Physical size: 3"x3.1"

Weight: 20 oz.

Filter size: 72mm Lens hood: HK-7

M.F.D.: 1.1'

Aperture Range: f/1.4-f/16

This is a new f/stop for this traditional wide angle. For many years, an ultra fast wide angle has been on the minds of many photojournalists who use the Nikon system. The 28mm f/1.4 combines a fast f/stop, autofocus and "D" technology, creating a valuable tool for photojournalists. Its use though is not limited to just photojournalists, neither are the techniques that they apply to photography.

This lens is designed specifically for low-light level shooting. This, along with its narrow depth of field is exploited by photo-journalists. In a confusing crowd on the courthouse steps, being able to use a narrow depth of field to focus in and isolate the defense attorney is critical (the 28mm does not distort the human shape). Remember that photography is the art of communication. The isolating qualities of the 28mm f/1.4 are magnificent, whether its being used on courthouse steps or in a meadow photographing a deer.

Aiding in this isolation is the use of flash; this is enhanced by the "D" technology and the N90/F90 camera body. Refer to the

Magic Lantern Guide to the SB-25 Flash System to make the most of this technology.

These same techniques and advantages can be applied to other facets of photography. photographers Nature can get close to capture that spectacular wildflower. Sports photographers can apply this to the players, advertising photographers to product. The lens might have the photojournalist in mind, but it is surely not limited to that use.

A benefit photographers often forget that comes with the fast f/stop is the ability to use a fast shutter speed. That photo-

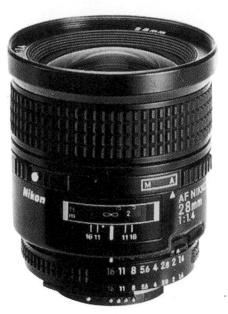

Nikkor 28mm f/1.4D AF

journalist chasing the attorney down the steps will appreciate the fast shutter speed afforded by the 1.4 f/stop. This advantage for the majority of photographers does not justify the price of the lens. And since the majority of scenic shots do not have to be chased down, many nature photographers might pass by the 28mm f/1.4. That could be a mistake depending on your style of photography.

Nikkor 28mm f/2

Original release: 1971 Angle of coverage: 74 ° Unique features: CRC Physical size: 2.5"x2.7"

Weight: 12.1 oz.

Filter size: 52mm Lens hood: HN-1

M.F.D.: 0.85'

Aperture range: f/2-f/22

The 28mm f/2 is an excellent lens, of the quality which Nikon is famous for producing. But this lens has never been popular, typical for its focal length. The f/2 model was designed with available light photography in mind. This can be a big asset for photojournalists, but even they have never embraced this lens.

Because of this, there are no particular tricks of the trade as so few own or use this lens. Nikon's promotional material states this lens is ideal for "candids, group shots, land- and cityscapes, travel photography, architecture and interiors," all very true but the same can be accomplished by other lenses that are even more versatile.

Nikkor 28mm f/2.8N AF

Original release: 1991 Filter size: 52mm Angle of coverage: 72° Lens hood: HN-2

Unique features: none
Physical size: 2.5"x1.5"

M.E.D.: 1'

Weight: 6.8 oz. Aperture range: f/2.8-f/22

The 28mm f/2.8N AF, like all other 28mm lenses (except 28 f/1.4) has never found a place in photographers' camera bags. This small, compact lens with really remarkable quality has the stigma all 28mm lenses have, "just not very wide."

The 28mm is considered the "standard wide angle." This is another way of saying not a normal lens and not a wide angle. They are fairly easy to find used which is an excellent way to add it to your camera bag. Again, probably the biggest drawback to selling these lenses is the fact camera stores do not have the Grand Canyon in their showrooms. Its "not-so-wide" angle is hindered by the walls of the showroom.

Stretching the 28mm's angle of view is possible for scenics. It does require using every technique described with other wide angles plus a good eye and some imagination. The 28mm does tend to be less effective at a low angle and better at higher angles compared to other wide angles.

This is one of the marvelous lenses that can be reversed (BR-2 ring required). On a bellows, for example, this lens can deliver 9x magnification with an excellent free working distance. On a body, a magnification of nearly 2x is delivered. The quality of the

optics are not compromised by reversing it, delivering outstanding performance. For those wanting to explore macro photography (especially on a budget), this is a great option.

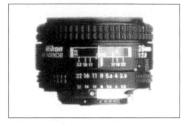

Nikkor 28mm f/2.8N AF

Nikkor 28mm f/3.5 PC

Original release: 1981

Angle of coverage: 74°, 92° when

shifted

Unique features: Perspective

Control (PC)

Physical size: 3.1"x2.8"

Weight: 13.4 oz.

Filter size: 72mm

Lens hood: HN-9

M.F.D.: 1'

Aperture range:

f/3.5-f/22, manual

The most unique in the 28mm focal length, it is also the most used. It gets its name "PC" because it offers Perspective Control of vertical or horizontal lines. It is able to do this because the lens barrel "shifts" which is critical in its application. When the lens is not shifted, it has an angle of view of 74 degrees. This increases to a maximum of 92 degrees when shifted (this is equivalent to the coverage of a 24mm lens).

The key to using the 28 PC is keeping the camera back parallel with the subject at all times. This prevents any lines, either vertical or horizontal, from bending due to distortion. This will not be the correct framing of the subject though. The subject will more than likely be cut in half when the camera back is kept parallel. This is not a problem though as the lens shifts to "pull" the subject completely into the frame. This is because the front element section of the lens physically moves which increases the angle of view and brings the rest of the subject into the image area.

The amount the lens can be shifted is determined by whether the camera is vertical or horizontal. When horizontal, the lens only has 8mm of shift compared to 11mm when vertical. The lens is most typically used in a vertical format to maximize shift. And since most buildings, statues, trees and the like are vertical subjects, this works out to the advantage of the photographer.

Because the lens barrel shifts, there is no automatic aperture linkage. This means the lens has a manual aperture, being operated by the photographer. The photographer must take a meter reading prior to any shifting and predetermine the proper exposure. This is accomplished by turning the main aperture ring which operates the aperture blades. The photographer can then turn a secondary ring (not connected to the aperture blades) to the desired f/stop to lock in the exposure for later reference. The main aperture is then opened back up for bright viewing, shifting and focusing. Once shift and focus are accomplished, the main aperture ring is turned to close down the aperture to match the preset secondary ring for correct exposure.

This lens can also be used as a standard 28mm lens, but because of the manual aperture, it is slow to operate.

Nikkor 35mm f/1.4

Original release: 1970 Angle of coverage: 62°

Unique features: CRC

Physical size: 2.7"x2.9"

Weight: 14.1 oz.

Filter size: 52mm Lens hood: HN-3

M.F.D.: 1'

Aperture range: f/1.4-f/16

With sixteen degrees wider coverage than a normal lens, the 35mm is for many their normal lens. The 35 f/1.4 in particular is selected with its extremely fast f/stop, great for low light and/or interior photographs. But the fast f/stop of the 35mm f/1.4 is only a hint of the tremendous quality this lens can deliver.

One of the first lenses to be introduced with multi-coating, the current 35 f/1.4 delivers incredible clarity. Its slightly higher than normal contrast leads many to think this lens was made with photojournalists in mind. In fact, many photojournalists do have this lens in their bag, but in watching photojournalists in action, fewer and fewer tend to be making this their normal lens.

The 35mm f/1.4 is the only 35mm that has CRC. This is what partly gives the 35 f/1.4 its "extraordinary resolution." The edge-to-edge sharpness is quite remarkable compared to the majority

of lenses on the market. In Nikon promotional material for the 35mm f/1.4, it was said to be "ideal indoors or out, ...snapshots, candids, portraits of people in their surroundings." Some of the most famous news portraits taken of prominent figures of our time are testament to this!

The 35 f/1.4 is rarely used in close-up photography and almost never reversed. It has been pigeon-holed probably more than any other Nikkor lens. This is a testament to its quality, but a loss of potential images. Since lately they can be found on the used lens shelves with more frequency, we will probably see it used in more applications in the future as photographers discover it can do much more than just capture snappy black and whites.

Nikkor 35mm f/2 AF

Original release: 1988 Angle of coverage: 62°

Unique features: none Physical size: 2.5"x2.1"

Weight: 7.5 oz.

Filter size: 52mm Lens hood: HN-3

M.F.D.: 0.9'

Aperture range: f/2-f/22

The 35mm f/2 AF is an excellent choice for a first lens-with-body purchase. Its small size, sharp optics and reasonable price are just

a couple of the reasons this lens is an excellent choice. It is one of only three, originally released autofocus lenses not to be modified or discontinued since its release.

This is the closest focusing 35mm lens in the Nikon system. Many nature photographers enjoy using the 35mm in this way, which includes adding a small extension tube such as the PK-11a. Many also use this lens reversed as it produces excellent results. Reversed on a body, this lens renders a mag-

Nikkor 35mm f/2 AF

nification of approximately 1.5x. Many use it on a bellows producing a magnification of up to 6x. Because of the remarkable edge-to-edge sharpness of the lens, using it in any of these ways renders excellent quality.

One of the traits of this lens lost on most is its quick focusing. This reference is not to its autofocus capability, but to how little effort is required to focus the lens from its minimum focusing distance to infinity. The travel distance from these two points is slightly less than 180 degrees. Manual focus is extremely fast because of this, making capturing moving kids for example, easy. In autofocus, its extremely quick, making it a joy to use.

An old trick of photojournalists is to "shoot from the hip." This is a technique that is further refined with the AF attributes of the 35mm. When photojournalists want to take a photograph inconspicuously, they shoot with the camera hanging from their shoulder, at their hip. For photographing shy subjects or getting photos in compromising situations, this lens and old technique work marvelously together!

Nikkor 35mm f/2.8 PC

Original release: 1974 Filter size: 52mm Angle of coverage: 62°, 74° when Lens hood: HN-1

shifted

Unique features: Perspective M.F.D.: 1'

Control (PC)

Physical size: 2.4"x2.6"

Weight: 11.3 oz. Aperture range: f/2.8-f/32

The first lens of its type, the current version of the 35 PC is cosmetically and functionally the best. It is physically shorter and smaller than the 28 PC and has a 52mm filter size. But its functions are the same as the 28 PC when it comes to operation.

Metering and focusing should be done prior to shifting. The 35 PC has a maximum of 11mm of shift with the camera vertical and 8mm of shift with the camera horizontal. When fully shifted, the

This Barrel Cactus standing in the mid-day sun was photographed with a 55mm f/2 AF.

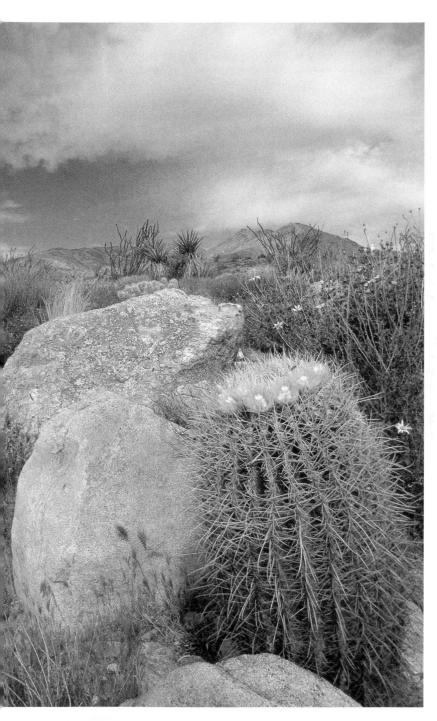

angle of coverage is the same as a 28mm lens (74 degrees). The aperture is manual. The photographer must manually open it up to focus then close it down to take the photograph. Refer to 28 PC for complete description of this operation.

Unlike the 28 PC, the 35 PC is not very popular and thus, not in general use. The 35mm film format is not like a 4x5, it has very little room for shifting and correction. The 35 PC can be fully shifted and barely correct the image. The 28mm provides the greatest amount of coverage in this situation which is why it overshadows the 35 PC.

Nikkor 50mm f/1.2

Original release: 1979
Angle of coverage: 46°
Filter size: 52mm
Lens hood: HS-12

Unique features: none

Physical size: 2.7" x 2.3" M.F.D.: 1.7"

Weight: 13.4 oz. Aperture range: f/1.2-f/16

Nikon's promotional material says of the 50 f/1.2, "tremendously versatile." This is hard to swallow for the majority of photographers because even though it has a fast f/stop, it is still a 50mm lens. Nikon's material goes on to say, "ideal for candids, scenics, and available-light shooting."

The f/1.2 is the fastest f/stop available in the Nikon system. This f/stop is best known in connection with the 58mm f/1.2 Noct, but in the 50 f/1.2, it costs a lot less. The 50mm f/1.2 delivers marvelous sharpness, and is extremely well-corrected for coma and spherical aberrations. It flares a tad with a point light source so it is no 58mm f/1.2, but it delivers excellent results!

One place this lens has really excelled is in theater photography. This is a situation where its f/1.2 is indispensable as flash is not allowed. It is also an application where the "normal" angle of view works well as live theater naturally is seen this way. Those photographers using the lens in this manner tend to apply it in the same way outside the theater.

Some photojournalists use this lens to take candids on the sly. With today's faster films, shooting wide open permits leaving the flash off. The difference between f/1.4 and f/1.2 is not quite 1/2 of

Nikkor 50mm f/1.4N AF

Nikkor 50mm f/1.8N AF

a stop, but in low light situations it can make all the difference. This is especially true if using a camera with a stepless shutter where the exposure is not locked in by manual shutter speeds.

Nikkor 50mm f/1.4N AF

Original release: 1991 Angle of coverage: 46°

Unique features: none Physical size: 2.5"x 1.6"

Weight: 7.4 oz.

Filter size: 52mm

Lens hood: HR-2

M.F.D.: 1.5'

Aperture range: f/1.4-f/16

Photographers often wonder why "normal" lenses are still manufactured. With all the bad press about being stuck with a "normal," why would anyone buy one? The 50mm f/1.4N AF fits this general consensus. The exception is the young photographer whose first camera comes with a 50mm lens.

The reason for this is because they do not know that they

shouldn't like the lens. They explore every nook and cranny of their world through the normal perspective. Generally they capture some remarkable images as they do not know they shouldn't. Many "seasoned" photographers could learn from these young photographers and attempt photographing their world through a normal perspective.

If a photographer were to take up this challenge, the 50mm f/1.4N AF would be a great lens to do it with. It is physically small and light, making it easy to use. Its image quality is excellent and contrast very snappy. It is an excellent lens to manipulate with either extension tubes, teleconverters or reversing rings. In any of these applications, the lens performs with resounding quality.

Nikkor 50mm f/1.8N AF

Original release: 1989 Filter size: 52mm
Angle of coverage: 46° Lens hood: HR-2

Unique features: none Physical size: 2.3"x1.5"

Weight: 5.5 oz. Aperture range: f/1.8-f/22

When a camera store sells a camera body, it is typically with a 50mm f/1.8 to keep the package price as low as possible. This is probably why there are more 50 f/1.8 lenses lining the shelves of used departments than any other lens. This is really quite criminal as it is an excellent lens.

M.F.D.: 1.5'

The 50 f/1.8N AF is the best of all versions of this lens. Its very compact size makes it one of the smallest lenses in the Nikon system. Its ease of focus and bright viewing make it a joy to use. Best of all, its low price makes it simple to own and keep.

Many of today's lenses are of moderate speed. Wide angles, zooms and macro lenses have apertures starting at f/2.8 or f/3.5 making them hard to use in low light situations. With its wide availability, excellent image quality and affordable price, the 50mm f/1.8N AF is an excellent choice for low-light backup. Because the lens is often discarded, picking one up used for basically nothing is relatively easy. If speed needs to be interjected into a lens system, this is a terrific choice.

This photo of the Santa Barbara Courthouse is a perfect example of why a 50mm lens should not be overlooked.

Telephotos

Tricks of the Trade

The lenses in this range were specially designed for taking head-and-shoulder candids. The 85mm, 105mm and 135mm focal lengths, since their introduction, have always been thought of as "portrait lenses." This is because these lenses render a perspective that places the nose in proper size relationship to the face. At the same time, these focal lengths provide a comfortable working distance between the photographer and subject.

If all these different focal lengths are considered portrait lenses, which is the right one to own? The answer comes from ones own personal style. The intimate photographer would like the 135mm, the shy would pick the 85mm and those in the middle of the road would select the 105mm. Comparing the picture angle of the three focal lengths from the same distance, the 135mm would frame just the head, the 105mm the head and shoulders and the 85mm the head and upper torso.

The 180mm and 200mm fit into this category as they are prime lenses used by photojournalists for portraits. Most photographers own or have owned at least one of these two focal lengths at some time. Their legendary optics and "normal" perspective are excellent for portraits, sports, wildlife and scenic shots. They are also small enough to permit handholding, even in low light.

Isolating the Subject

All current telephotos are fast, something reflected in their higher price. This need for speed relates to the narrow depth of field inherent in their design, making them suitable for many different tasks in photography. The combination of their narrow angle of view and shallow depth of field makes them a natural for isolating a subject. For portraiture, this is a must!

The techniques used for isolating a subject with a telephoto differ from that of a wide angle. The main principle of isolating is to manipulate the background with the narrow angle of view of the telephoto. Where a wide angle captures all, a telephoto only gets slices. By moving the telephoto laterally, or up and down, different slices of the background can be placed behind the subject. This permits a light subject to be placed in front of a dark area or dark in front of light. In either case, the background will isolate and help the subject to *pop*. Adding to this technique of isolation can be the shallow depth of field when these fast lenses are shot wide open.

Compacting the Scene

Telephotos starting at the 180mm range tend to compact a scene. This can be seen in a scenic when a farm house appears to have far off mountains in its backyard. This principle is used quite often in the movie industry. Those cars in the car chases are not as physically close as depicted, but optically compacted on top of each other by telephoto lenses. This is one of the great tricks of the trade.

Other tricks of the trade involve additional accessories. All of these lenses accept filters, multiple ones if required. They either come with shades from the factory or have them built-in. These need to be used even if filters are in use. Telephotos can flare just as any other lens, but the flare is much harder to detect with the inexperienced eye.

Flare

Flare in telephotos is "textbook," the flattening of contrast and color. Telephotos generally do not produce the colored UFOs typical of ultra wides and wide angles. Telephoto shots have a lackluster appearance when afflicted by flare. It takes only a slight ray of light on the front element to create flare. Ridding the front element of this light can be difficult and often the best option is finding the shade of a building or tree to shade the front element. Going out and purposely creating flare to see its effects is a smart idea so it can be recognized when it occurs when actually shooting.

Sharpness

Proper technique for handholding assures capturing all the sharpness these lenses can deliver. Refer to page 49, to review proper handholding technique.

This shot of a nesting Anna's Hummingbird feeding its young was captured with a 200 mm f/4 IF.

Nikkor 85mm f/1.4

Original release: 1982 Filter size: 72mm Angle of coverage: 28°30′ Lens hood: HN-20

Unique features: CRC

Physical size: 3.2"x2.9" **M.F.D.:** 3'

Weight: 21.9 oz. Aperture range: f/1.4-f/16

"Natural perspective and superlative image sharpness" is the leading phrase Nikon uses to describe the 85mm f/1.4. Those who have shot with this lens would probably find this to be an understatement. This is one of the lenses all have heard of, a lens many aspire to own, someday.

Its large, 72mm sparkling front element is a big part of its allure but it is only a hint of the magnificent array of elements making up this lens. The highlight is in the rear where Nikon incorporates CRC. Technically, CRC only goes into effect when a lens is focused close to its minimum focusing distance. But the incredible edge-to-edge sharpness of this lens at all focus points, tends to make one think that CRC effects the total optical performance.

The extremely narrow depth of field of the lens is one of its biggest attributes. Photographers buy this lens initially because of its speed and apparent ability to shoot in low light. They quickly find out that its narrow depth of field isolates a subject so remarkably that it can communicate like few other lenses. It makes incredibly fast shutter speeds available with a small telephoto that's great for many outdoor sports.

The 85 f/1.4 is unique in one other way, it is only used as a straight lens. Where most lenses are used with an extension tube, teleconverter or for doing close-up work, the 85mm f/1.4 is not. This is not to say it does not work well in these different ways, it does. But it is such a superior lens as is, photographers do not use it any other way.

So, most photographers do not know that when used with the TC-201 or TC-14A at f/11 or slower with fast shutter speeds, there is a possibility of uneven exposures. This is information Nikon provides in its promotional material for the lens however, this problem rarely if ever occurs since the lens is seldom used in this fashion.

Nikkor 85mm f/1.8 AF

Original release: 1988 Angle of coverage: 28°30′

Unique features: none Physical size: 2.8"x2.7"

Weight: 14.6 oz.

Filter size: 62mm Lens hood: HN-23

M.F.D.: 3'

Aperture range: f/1.8-f/16

The 85mm f/1.8 AF is one of the original autofocus lenses to be released by Nikon. It is also one of three original autofocus lenses never to be modified or discontinued since its release. Nikon's first 85mm f/1.8, a remarkable lens, was introduced in 1964, only to be later replaced by the 85 f/2. The 85mm f/1.8 AF carries on the legend of the original 85mm f/1.8, being a prime lens many photographers carry in their camera bags.

Its small, compact size and light weight, make it an outstanding lens to handhold in low-light situations. It is one of a few autofocus lenses manufactured by Nikon that is truly fast when autofocused by the camera. This is partly because of its bright image which makes it easy for the AF sensor to operate. But more because the focus throw on the lens is so short, it takes little effort of the camera's AF motor to focus the lens.

It is an excellent lens to use with extension tubes. Its minimum focusing distance is not any less than a standard 85mm lens which is unusual for autofocus technology. Its edge-to-edge

sharpness, when used with an extension tube, is remarkable. For example, the addition of the PK-11a (8mm tube) brings the minimum focusing distance down to twenty-four inches. This provides nearly a 1:3 magnification with excellent working distance and image brightness. There is the loss of matrix metering when an extension tube is added, but that is the only drawback to extending this lens.

Nikkor 85mm f/1.8 AF

This makes the 85mm f/1.8 AF an extremely versatile lens. Whether using it for its designed purpose of portraiture, adding an extension tube for macro work or capturing tack-sharp scenic shots, it is one of the best all around lenses in the Nikon system.

Nikkor 105mm f/1.8

Original release: 1982 Angle of coverage: 23° 20′

Unique features: none Physical size: 3.1"x3.5"

Weight: 20.5 oz.

Filter size: 62mm Lens hood: built-in

M.F.D.: 3.5'

Aperture range: f/1.8-f/22

The first thing that is so overwhelming about the lens is its bright image. Using it in low-light situations or with a polarizer attached is never a problem with this bright lens. Added to this, are the incredible images the lens can produce which made it extremely popular at its introduction.

Compared to the 105 f/2.5 and 105 f/2.8 micro which were on the market at the same time, the 105 f/1.8 is physically large. It is the only one of the three to have a 62mm filter size, and the only one in the entire Nikon system to have this filter size at the time. Of course today, the 62mm filter size on Nikkor optics is normal, but in 1982, 52mm was the norm. This probably is what kept the 105mm f/1.8 from widespread ownership as few wanted to invest in a second set of filters.

Those who own it just love using it for portraiture. Its narrow depth of field and tack-sharp image are a natural for portraiture. Though not described as having CRC in Nikon literature, its image quality would suggest that it has. It still is used in sports photography, especially indoor events such as basketball or gymnastics where its narrow depth of field isolates the player from the crowd. Its speed also enables the use of fast shutter speeds and the fast f/stop gives extra distance to flash.

Extending the lens with an extension tube or teleconverter is not the norm with the 105mm f/1.8. Those who own it tend to use it for the main purpose it was designed for, but this does not mean it performs poorly with these attachments. Since its mini-

mum focusing distance is minimal, adding 50mm or more of extension is necessary to create any significant magnification.

When used with the TC-201 or TC-14A at f/11 or slower with fast shutter speeds, there is a possibility of uneven exposures. This is information Nikon provides in its promotional material for the lens. This is a problem though that rarely, if ever, occurs when using it.

Nikkor 105mm f/2D DC AF

Original release: 1993 Filter size: 72mm Angle of coverage: 23° 20′ Lens hood: built-in

Unique features: DC Image Control,

RF system

Physical size: 3.1"x4.1" **M.F.D.:** 3.3'

Weight: 22.5 oz Aperture range: f/2-f/16

The 105mm has been thought of generally as "the" portrait focal

length. To make it even more so, Nikon manufactures the 105mm f/2D DC AF (just saying the nomenclature takes an hour). The 105 f/2D DC AF incorporates Nikon Defocus Image Control (DC) and Rear Focusing (RF) system.

The DC Image Control allows the photographer greater creative control on which elements are out of focus and by how much. By turning the DC ring, the elements in front of the focused subject or behind the focused subject can be thrown out of focus. This is in addition to depth of field. To assure an even, soft blur to the image, additional blades are incorporated in the aperture design (to create a more roun-

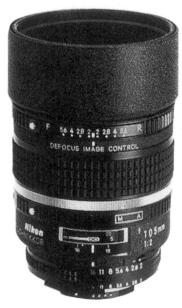

Nikkor 105mm f/2D DC AF

ded opening). Any out of focus elements at any f/stop are complemented and softened by this design.

The RF focusing system can be thought of as internal focusing. When the lens is focused, the RF system moves the rear lens group internally to focus the image. This keeps the physical length of the lens constant. This also makes the autofocusing speed amazingly fast. The optics also have a dust proof rear glass plate to prevent any dust from getting into the internal optics.

It is a pricey lens, but is its only use portraiture? What if one wanted to photograph wildlife behind wire cages at the zoo? The DC Image Control set to front can make that wire disappear. What about photographing race cars on a track, lots of depth of field could be used and with the DC set to rear, the grandstands disappear! The DC Image Control has many applications. Probably every photographic situation where the photographer wants complete control over all the elements in the photograph could be solved with this lens.

Nikkor 105mm f/2.5

Original release: 1959 Angle of coverage: 23° 20'

Unique features: none Physical size: 2.5"x3.1"

Weight: 15.4 oz.

Filter size: 52mm Lens hood: built-in

M.F.D.: 3.5'

Aperture range: f/2.5-f/22

One of the first lenses ever to be introduced by Nikon, the 105 f/2.5 has long been a legend. It has gone through more cosmetic changes than any other Nikkor lens through the years with virtually no change to the optical formula. Sizing down and addition of NIC have made the current 105 f/2.5 the best of all the versions.

When photographers think portraiture, they think 105 f/2.5. This is where this lens has been pigeon-holed since its introduction. This is simply because its angle of view and picture coverage most typifies what photographers want in a portrait. In the 1980s, this lens was especially popular with fathers photographing their new arrivals. Its small size and very reasonable price made it a natural for just such events.

With the advent of zooms in the 35-105 range, the popularity of a prime 105mm lens has fallen off. This is also partly because the 105mm f/2.5 has never been applied to other photographic situations, limiting its perceived versatility. Very few photographers combine the lens with an extension tube or teleconverter. This is further hampered by the fact that the 105 f/2.8 AF micro focuses down to 1:1 without any tubes.

Use with the TC-14A can lead to "occasional vignetting" according to Nikon's literature, but this is a very rare occurrence.

Nikkor 135mm f/2

Original release: 1976 Filter size: 72mm
Angle of coverage: 18° Lens hood: built-in

Unique features: none Physical size: 3.2"x4.1"

Weight: 30.4 oz. Aperture range: f/2-f/22

M.F.D.: 4.5'

This is one meaty lens! Its large 72mm front element provides the light gathering qualities that make it an f/2, but it also makes it big. This big piece of glass also makes it heavy. It also makes it very sharp and in a world of autofocus lenses, still a popular lens.

The 135mm focal length, in general, died as a prime lens in the early 1980s (though the 135mm focal length is a popular setting when using a zoom). Special lenses such as the 135 f/2 are what kept it alive as a prime lens. This is best described by Nikon's promotional material which states, "Eye-arresting telephoto effects with highly flattened perspective and isolation of the subject from the background."

Photojournalists have long liked using this lens for these reasons (plus the weight of it makes a good weapon). Compacting and relating two elements in a photograph while isolating them from other elements is the cornerstone of the 135mm f/2's popularity. Photographs taken with it are distinctive and when coupled with a photographer's personal style, it is a powerful way to communicate.

Those talented wildlife photographers who know how to get physically close to big game also like this lens. It renders the large bulk of big game accurately while its f/2 isolates the subject

from its environment. Although this is a very special application and not one recommended to most nature photographers, it is something to keep in the back of one's mind.

It is also used in indoor sports though it's slowly being replaced by the fast f/stop autofocus zooms. Like the 85 f/1.4 and 105 f/1.8, using the 135 f/2 with a TC-201 or TC-14A at f/11 or slower with fast shutter speed, might cause uneven exposures.

Nikkor 135mm f/2 DC AF

Original release: 1990 Filter size: 72mm
Angle of coverage: 18° Lens hood: built-in

Unique features: Defocus Image

Control

Physical size: 3.2"x4.2" M.F.D.: 4'

Weight: 30.5 oz. Aperture range: f/2-f/16

The 135mm in the early 1960s was considered "the" portrait focal length. Long ago it lost that niche but Nikon is bringing it back in the 135mm f/2D DC AF (a tongue twister in lens descriptions). Like the 105mm f/2D DC AF, the 135mm f/2D DC AF incorporates Nikon Defocus Image Control (DC) and Rear Focusing (RF) system.

The DC Image Control provides the photographer control over which elements are out of focus and by how much. Turning the DC ring manipulates elements in front of the focused subject or behind it to be out of focus. This can be done to varying degrees in addition to depth of field control. Complementing this is a rounded aperture to assure a soft blur to any out of focus elements at any f/stop selected.

The RF focusing system can be thought of as internal focusing. When the lens is focused, the RF system moves the rear lens group internally to focus the image. This keeps the physical length of the lens constant. This also provides lightning-fast autofocus response. The optics also have a dust proof rear glass plate to prevent any dust from getting into internal optics.

It wasn't long after its introduction that the lens was in wide use in the fashion industry. In photographing runway models, the ability to make elements in the background disappear is a tremendous advantage. It has also found a home photographing

The Stowe House as photographed on a bright spring day with a 35mm f/2 AF.

These glowing Bigelow Chollas were captured at sunrise with an 85 mm f/1.8 AF.

Nikkor 135mm f/2 DC AF

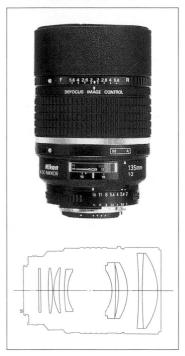

indoor sporting events for the same reason. It hasn't been popular with the general photographic market though because of its price, a fact that probably will not change with time.

Nikkor 180mm f/2.8N ED IF AF

Original release: 1988 Angle of coverage: 13° 40′

Unique features: none Physical size: 3.1"x5.6"

Weight: 25.2 oz.

Filter size: 72mm Lens hood: built-in

M.F.D.: 5'

Aperture range: f/2.8-f/22

One of the original lenses to be released with autofocus technology, the 180mm f/2.8N is the third version. When first introduced, it had the reputation and legendary status of the manual version to compete with which was formidable. It wasn't until this latest version (changes have only been cosmetic) that the legend of the manual version has been finally put to rest.

Nikkor 180mm f/2.8N ED IF AF

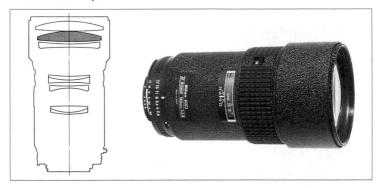

The 180 f/2.8N is a very versatile lens. Its prime use has always been in photojournalism. Its fast f/stop, shallow depth of field and great reach made it a natural for that application. These same attributes have been applied to fashion photography as well. But the sexiness of the manual and autofocus versions have endeared it to all photographers who put it to many uses.

It is a very common lens in macro photography, a surprise? It is quite often coupled with the PN-11 extension tube rendering almost 1:2 magnification. It is used quite often with the TC-201 making a 360mm f/5.6, excellent for wildlife photography. Its minimum focusing distance is still five feet, but it has the magnification of 360mm with very limited depth of field, great for isolating the subject. This is especially true when photographing big game, whether with a teleconverter or not.

The lens though slightly on the heavy side, is still quite easily handheld. Its price is not outrageous, being well within the range of most photographers. All of these factors are what make the lens so popular. Its extreme flexibility in so many facets of photography makes it an excellent choice for many photographers focusing in on so many different subjects.

Nikkor 200mm f/2 ED IF

Original release: 1980 Filter size: 122mm (not

usable) gel holder Lens hood: HE-4

Angle of coverage: 12 ° 20′

Unique features: none

Physical size: 5.4"x8.7" **M.F.D.:** 9'

Weight: 84.8 oz. Aperture range: f/2-f/22

This is one of Nikon's least known lenses. Short, stubby and with a 122mm front element, the very profile of the 200mm f/2 is often mistaken for a 300mm f/2.8. When first introduced, the lens was gobbled up, but with the introduction of other fast telephotos and the 180 f/2.8 only a stop slower and considerably smaller, it has lost many of its early supporters.

It is not so large that it cannot be handheld, but it does require a sound technique and a little arm strength. The lens is still widely used in sports photography, especially indoor sports. It seems to be losing its hold there though with the fast f/stop ED autofocus zooms now available.

Because of this, there are many on the used lens market at a fairly low price. Many photographers are now finding out that the lens is a real jewel when used with an extension tube for macro work. It works great with the TC-14B, making it a 280mm f/2.8 lens. It also works with the TC-301 making an excellent 400mm f/4 able to focus down to nine feet! (Do not use with TC-201 or TC-14A, image quality at the corners suffers.)

Page 81:

With the most important subject closest to the lens, it is easy to show how objects relate to one another with the 20mm f/2.8 AF.

Page 82:

The haunting beauty of a wildfire is heightened by the crystal-sharp rendition of the 58mm f/1.2.

Page 84, top:

The triumph of conquest of the "giant" rock is captured from a distance with the 300mm f/2.8N AF.

Page 84, bottom:

Exploring nature is the wonder of youth and the joy of photographers capturing it on film. Taken with the 300mm f/2.8N AF.

Page 85:

The simple elegance of an emerging Monarch Butterfly was captured in the studio with a 60mm f/2.8 AF and flash.

Page 86:

The isolating power of the 300mm f/2.8N AF lets ones imagination give shape to even naked rock.

Page 87, top:

Bringing home the desert night sky is done with a 20mm f/2.8 AF and a six hour exposure to the heavenly lights.

Page 87, bottom:

The desert brittlebush becomes a graphic motif when isolated against its rocky home by an 800mm f/5.6.

Page 88:

By adding an extension tube to the 20mm f/2.8 AF the poppies in the background were blurred to make those in foreground "pop."

Nikkor 200mm f/2N ED IF

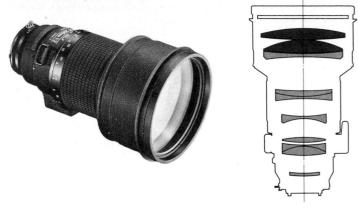

It is a great lens for big game work. The comfortable working distance between the subject and camera and its excellent magnification and isolation ability make it a natural for this type of photography. And because it is so fast, available light photography can be squeaked out to the very last ray of light. For many big game mammals, this is ideal!

With speed such a big factor in many lens purchases today, the 200mm f/2 is an excellent choice. With the mainstream, fast prime lenses in great demand, their price is always high and availability low. The 200 f/2 is an excellent way to break into "speed" as it is normally lower priced and easier to find. There is no sacrifice though in quality, versatility or function in buying a 200mm f/2! For those wanting to break into fast telephotos without breaking the budget, this is the best buy around!

A field of Cupped Monolopia captured on a breezy day with a 20mm f/2.8 AF.

Super Telephotos

Tricks of the Trade

By far, this is the most glamorous group of lenses in photography! These lenses are aspired for more than any other, whether by fashion, sport, wildlife, industrial or armchair photographers. By seeing the sidelines filled with sports photographers and their long lenses, or the fashion runways lined with huge front elements glistening in the lights, photographers are bombarded with the allure of the super telephoto.

There is no mistaking it, the photographs taken with these lenses are some of our most memorable. There is one simple reason for this, angle of view. Telephotos have a very narrow angle of view providing an incredible amount of control over the background. The photographer understanding this, manipulates the background to support the subject while at the same time isolating it. This is the cleanest and purest form of communication available in photography.

Where wide angles take in all of the background and telephotos capture slices, super telephotos reveal only slivers. Literally, a lateral movement of only a few inches can radically change the background when using a super telephoto. Mastering the technical side of using these lenses is easy, but mastering manipulating the background takes imagination and talent. Those who excel with telephotos are those who have mastered isolating the subject by selecting the right background.

Lens Speed

Buying one's first super telephoto can be a trying situation. After the question of focal length is resolved, the problem of which f/stop arises. Fast telephotos have become the demigods of photography with few understanding why. True, some photographers use them in low-light situations, possibly extending shooting time a few minutes. But fast telephotos were not designed with that in mind. Speed was built into these lenses to further enhance their isolating power and provide the fastest possible shutter speed when using them.

The predecessors to modern telephotos had f/stops of f/4.5, f/5.6 and slower. They let background detail creep in, were dark to focus and so physically large that photographers had to sit in the grandstands rather than on the playing field to shoot. Further more, they were often shot partially closed down to obtain maximum results making them even slower and darker (no automatic aperture either). To solve all these problems, ED glass and Internal Focusing were developed.

The question still remains, does one buy a fast telephoto or slow one? What does a photographer gain by paying three or four times the price for one extra stop? They gain more isolating power and a lens three times larger. If a photographer is going after football players, that extra stop means the player on the field will pop from the crowd which has been rendered as a wash of color. That same lens, though, pointed at a bird would have to be closed down to gain enough depth of field for the eyes and beak to be in focus. If that is the case, spending the extra money for a lens that must always be closed down does not make sense. These are the pros and cons each individual photographer must answer; that and/or a spouse asking, "How much!?"

Filters

Super telephotos either have a 122mm or 160mm front element. Threaded filters this size are not available which is OK since Nikon's current super telephotos no longer accept filters in the front. The versions leading up to these super telephotos accepted filters; Nikon manufactured them. But they have been replaced with a built-in, permanent front "dust filter." Filtration is accomplished through a rear filter drawer in these lenses.

The 122mm class super telephotos accept a 39mm filter via the filter drawer. The 160mm class accepts 52mm filters via a filter drawer. The 52mm drawer will accept any standard 52mm filter, but the 39mm will only accept those in a Nikon 39mm filter mount. That is because, though the diameter of the glass is 39mm, the mount has a lip reducing the size to 33mm. Using these drawers for color correction or black and white filters is not a problem. But filters which need to be turned such as polarizers, cannot be used in these drawers.

There is a solution to using a polarizer with the 122mm-class super telephoto. *Kirk Enterprises* manufactures a 39mm polarizer

An endangered California Clapper Rail, caught with the long reach of the $800 mm \ f/5.6$.

that works marvelously in the filter drawer by providing an external dial to turn the polarizer to achieve proper polarization. There is no such product as of yet for the 160mm class, 52mm filter system super telephoto.

Focus Controls

All of these super telephotos have a prefocus click stop. This has caused more confusion for photographers than probably any other feature. It can be set to provide an audible and momentary "click" anywhere in the focus track. For example, a photographer shooting a baseball game could prefocus on second base for the eventual steal and set the prefocus click at that point. The lens could then be used to photograph the game and when the steal occurs at second, the lens can quickly be turned to the preset, prefocus click to capture the action.

These super telephotos can focus past their infinity mark. The ED elements in the super telephoto can be affected by *extreme* heat or cold. The elements can expand or contract with temperature affecting the way they focus. In -12° F temperature, my 800mm f/5.6 was affected and focused past the infinity mark, but this is rare.

Autofocus super telephotos have a focus-limiting switch and/or ring which helps speed up the autofocus operation. If the autofocus sensor has to find the subject only within a small range and not from infinity to its minimum focusing distance, it can do it much faster. Most lenses have three or four settings to limit the range of focus for this reason.

Lens Shades

Super telephotos come with a variety of shades. One type is built in to the lens and rotates in and out of place. The second one physically comes off and reverses into place on the first shade. Some lenses have just the reversible shade or just the one that pulls out, but many use the combination of both. Many photographers do not realize that they have a two part shade system. Read the lens' instruction manual carefully to take full advantage of all shades.

Super Telephoto Technique

Of course, if the subject is not in focus, all this is trivial. Using

telephotos successfully requires the proper technique. If one were to study telephoto design, it would be discovered that the focusing ring is directly above the tripod head (the exception is the 800mm f/8 and 1200mm f/11). An imaginary line should be drawn up the center column, through the tripod head and to the top of the lens (the focusing ring). Here is where a hand should always rest to minimize any camera/lens movement. Since the focusing ring is here, there should not be any problem doing this and focusing at the same time. The forehead/eye should be pressed against the camera back when firing to further eliminate any camera movement.

Transportation

These super telephotos all have strap lugs on their barrels. This is a hint from Nikon not to carry a big lens by letting it dangle from the camera's lens mount. The strap lugs on the lens are designed to support the weight of the lens and camera when carried. The weakest point of a lens/camera combo is the camera's lens mount

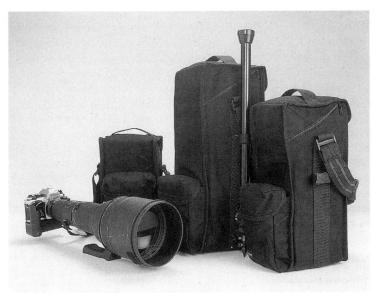

Domke's aptly-named "Long Lens Bags" ease the burden of carrying 300mm, 400-500mm, or 600mm telephoto lenses. The well-padded bag keeps a lens safe and accessible, whether mounted on a camera or not.

(just ask the photographer who was tackled at the football game). This applies to using a tripod as well. Attach the lens and not the body to the tripod when using a super telephoto.

One final note on the large trunk cases that come with these lenses. Many photographers wonder what the compartments are for in the interior. They hold the TC-301 and TC-14B teleconverters. Now these trunk cases do provide a lot of protection for the lens, but they are overkill. The Long Lens Bags manufactured by *Domke®* do a marvelous job, taking a lot less space while providing maximum protection and quick access.

Nikkor 300mm f/2.8N ED IF AF

Original release: 1988 Angle of coverage: 8° 10'

Unique features: none Physical size: 5.4"x9.8"

Weight: 89 oz.

Filter size: 39mm screw-in **Lens hood**: built-in & HE-6

M.F.D.: 10'

Aperture range: f/2.8-f/22

The manual version of the 300mm f/2.8 always overshadowed the 300mm f/2.8 AF and later the 300mm f/2.8N AF. Though the optical quality was as good if not slightly better in the AF version, the general "feel" of the lens was not as rock-solid as the manual version. The problem with this generally accepted sentiment is that many photographers are missing out on a great lens!

This is a remarkably sharp lens! It has a sexy front element (pictured on front cover) that just glistens, but that large element makes the lens barely handholdable for most. Many sports photographers use the lens with a monopod, others have them attached to tripods. The f/2.8 permits shooting at fast shutter speeds, but the narrow angle of view demands rock-solid technique for sharp images.

This lens does not have fast autofocus speed. Focus tracking is minimally effective with moving subjects with the "N" version. Most use this lens manually which is quite simple and can be quicker than the autofocus. The lens does not have a motor inside it but it does have a CPU.

The lens has a rotatable collar permitting 360 degree turning. This is indispensable when shooting vertically. It is much faster and sturdier than trying to turn a tripod head vertically. It also has

the two part shade system, one built-in and the other reversible. Combined, the two shades provide nearly seven inches of shade protection for the front element. The reversible shade is made of high impact plastic, the permanent shade is metal.

The lens can easily work with the TC-14B, providing outstanding results as a 420mm f/4 lens. With a TC-301 the results are not as outstanding, with the loss slightly noticeable at the edges. The PK-11a works marvelously on the lens, reducing minimum focusing distance to a little less than nine feet.

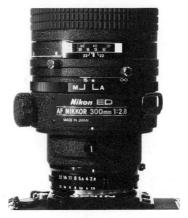

Nikkor 300mm f/2.8N ED IF AF

These can be found used at fairly decent prices because of the introduction of the AF-I version. For those wanting to get into a fast 300mm lens, finding one of these used is a great find. There is nothing optically or mechanically inferior with these lenses. In fact, it is one of Nikon's sharpest lenses but do not let out the secret!

Nikkor 300mm f/2.8D ED IF AF-I

Original release: 1992 Filter size: 39mm screw-in

Angle of coverage: 8° 10′ Lens hood: HK-19 Unique features: internal focus-

driving motor **Physical size:** 4.8"x9.5" **M.F.D.:** 10'

Weight: 102.4 oz. Aperture range: f/2.8-f/22

The lens the competition said could never be built! The 300mm f/2.8D ED IF AF-I (the I stands for Integral autofocus) is hands down one of the finest lenses on the market! It was long thought by many that Nikon could not incorporate motors into their lenses without changing the size of the lens mount (something

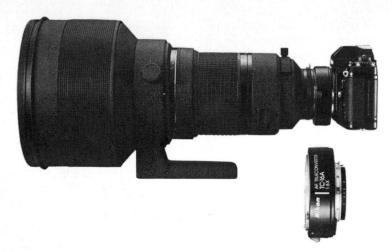

This Nikkor 300mm f/2 becomes a 480mm f/2.8 with the addition of the TC-16A teleconverter.

Nikon says they will never do). Well, Nikon not only put a motor into the 300 f/2.8D ED IF AF-I, but redesigned the optics and cosmetics to produce their best 300mm f/2.8!

The new built-in D/C coreless, focus-driving motor is the heart of the lens. This motor receives its power from the camera body. It also receives its focus input from the camera's autofocus sensor and focuses the lens accordingly. The AF motor in the body does none of the autofocusing, only the built-in focus-driving motor in the lens moves the elements. Nikon describes this motor as a "high-performance coreless motor" which is their way of saying its really fast!

Nikon went even further in their design. One main feature that must be pointed out is this lens does not need electricity to operate manually. If, for whatever reason, something should happen to the motor, the photographer is not left with a non-operational lens. For sports or wildlife photographers, this is very important. This means these lenses can work on older bodies not capable of AF operation. This maintains Nikon's credo of "planned absence of obsolescence in models to come."

The sharp point of this Agua Cactus remained sharp thanks to the acute resolution of the 105mm f/1.8.

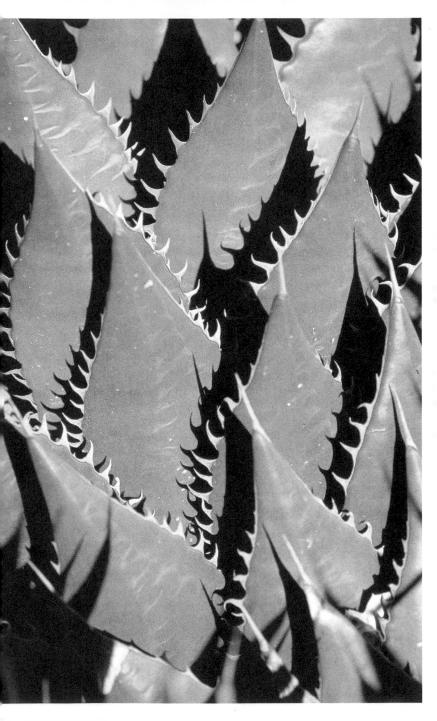

The lens has microcomputers (CPU) which communicate with the F4 and N90/F90. This includes the "D" technology needed for full operation with the N90/F90's flash technology. It also has a rotary encoder to assure exact focusing. And one final internal improvement is the elimination of the "autofocus" noise. Unlike its predecessors, this lens is whisper-quiet whether focused manually or automatically.

The lens also has some other new features. The unique M/A mode operates in the autofocus mode to provide quick manual override. In the M/A mode or when shooting normally in autofocus mode, the slightest touch of the lens focus ring coverts the lens to manual operation. This can be extremely useful in a situation where, for example, the lens is being panned and all of a sudden it is looking through a shrub. This might confuse the AF sensor, but a simple touch of the lens and manual focus is operational and the shot possible.

The autofocus lock on the lens is also redesigned. Four large (thumb nail size) buttons on the lens barrel between the front element and the focusing ring provide instantaneous autofocus lock. The focus range limiter incorporated into the barrel provides even faster response time working as other AF limiting switches (refer to 300mm f/2.8N). The filter drawer is still located in the lens barrel with the front element being a dust-proof plate.

The 300 mm f/2.8 AF-I can use two special teleconverters. The TC-14E is a 1.4x and the TC-20E is a 2x. Both of these teleconverters are tack sharp, both maintain complete electrical contact between the camera and lens. This means matrix metering and autofocus can be accomplished which wasn't possible prior to their introduction.

And even with all of these improvements, the lens is slightly shorter and easier to handhold. These are probably the main reasons this lens has been difficult to obtain since its release. Almost forgot to mention the optics. . . outstanding!

Nikkor 300mm f/4 ED IF AF

Original release: 1987 Filter size: 82mm front,

Angle of coverage: 8° 10′ Symm screw-in Lens hood: built-in

Unique features: none
Physical size: 4.1"x10.5"

M.F.D.: 9'

Weight: 46.6 oz. Aperture range: f/4-f/32

The 300mm f/4 ED IF AF made quite an impression when it was first released. Nikon's autofocus lenses were not receiving general approval or acceptance at this time. It is quite possible that the 300mm f/4 was most responsible for turning that around. The quality of this lens can be seen in the fact that its design has never been changed since its introduction. For those photographers wanting this focal length but not able to spend the big bucks on the one stop faster f/2.8, this lens is an excellent choice!

It is extremely sharp and handholdable making it a natural for almost all applications in photography. The placement of the wide-focusing ring is perfect for manual operation. When in auto-focus mode, the switch on the lens barrel can be flipped to lock the focusing ring in place, enhancing its use handheld. If this is not done, the focusing ring will turn when the lens is focused by the camera body. This can further delay the autofocus operation which is already slightly slow.

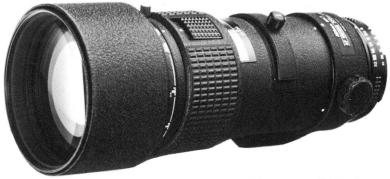

Nikkor 300mm f/4 ED IF AF

The lens is a natural for extension tubes and the TC-14B tele-converter. It is an outstanding 420mm f/5.6 lens, rivaling the 400mm f/5.6 ED IF. With the PK-11a extension tube, the minimum focusing distance is a little more than seven feet. With its built-in, 360 degree rotating tripod collar, the lens is marvelous for close-up work on a tripod. A teleconverter and extension tube can be used at the same time providing even greater magnification and versatility.

Another excellent application of this lens is with a combination of extension tubes. For example, by adding a PN-11 and PK-13 (80mm of extension) to the lens, it has the magnification of 1:2 with a three foot free working distance. Depth of field is a slight battle as the extension tubes have moved the lens away from the film plane, but the image quality is outstanding. One application for this would be photographing wildflowers.

The front filter size is 82mm which precludes using filters. It has a 39mm filter drawer as with other super telephotos. A polarizer can be used with the lens though via the *Kirk Enterprises* polarizer. If more than one filter is desired, a warming filter could be used on the front element in combination with one in the filter drawer.

This is a marvelous focal length for photographing big game. It compacts the animal enough to show off its size and strength, but not enough to distort it. It also provides a marvelous working distance with even the largest big game for both the photographer's and subject's safety.

If there was one lens I could recommend for the newcomer to super telephotos, this would be the one. Its versatility and quality are hard to beat. Its price leaves enough leftover to buy film to shoot with your new lens. This is one of the best new lens buys currently on the market!

Nikkor 400mm f/2.8D ED IF AF-I

Original release: 1993 Filter size: 52mm
Angle of coverage: 6° 10′ Lens hood: unknown

Unique features: internal focus-

driving motor

Physical size: 6.2"x14.8"

M.F.D.: 11'

Weight: 222 oz. Aperture range: f/2.8-f/22

At the writing of this book, this lens had yet to be released. Those tech reps at Nikon who have used the lens, report that it's "magnificent," functioning like the other two AF-I lenses currently available. The AF-I technology combined with the incredible optics of the manual 400mm f/2.8, (which are quite similar in construction as the AF-I) will make this a stand-out lens and one of the hot properties of the future!

An important attribute that we know about this lens before its release is its minimum focusing distance. Where all other Nikkor 400s have a minimum focusing distance of 15 feet, the AF-I minimum focusing distance is a mere eleven feet. This is a big plus for wildlife photographers where this additional four feet can make all the difference in the final photograph.

One would have to add a PK-12 onto the manual 400mm f/2.8 to achieve this same minimum focusing distance. And if the same extension tube had to be added to an autofocus version, matrix metering and autofocus ability would be lost. It is a tremendous advantage that the lens already focuses at 11 feet without a tube!

The 400mm f/2.8 AF-I accepts two special teleconverters. The TC-14E is a 1.4x and the TC-20E is a 2x. Both of these teleconverters are tack sharp, both maintain complete electrical contact between the camera and lens. This means matrix metering and autofocus can be accomplished which wasn't possible prior to their introduction

Nikkor 400mm f/2.8 ED IF

Original release: 1985

Angle of coverage: 6° 10'

Unique features: none Physical size: 6.4"x15.2"

Weight: 180.3 oz.

Filter size: 52mm screw-in

Lens hood: HF-3

M.F.D.: 15'

Aperture range: f/2.8-f/22

The 400mm f/2.8 has remarkable optics rendering incredible sharpness, color and contrast. It has also had a hard time finding a niche in the photography market. This is due to its physical size, price and similarity to the lower priced 400mm f/3.5. This is probably fine with those who own the lens as it is one of Nikon's greatest kept secrets. This lens is sharp!

Nikkor 400mm f/2.8 ED IF AF-I

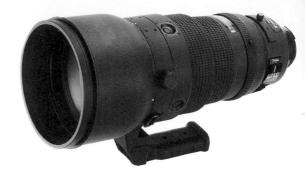

It is physically big, only inches shorter than the 600mm f/4. It has a 160mm dust proof front plate (accepting 52mm drop-in filters) and tends to be slightly front heavy because of the large front element array. This weight problem might be why it is not as widely used in sport photography as one might think. It is awkward to use on a monopod.

The 400mm f/2.8 is one of the best lenses for isolating a subject. This is still one of its biggest draws for many photographers. The narrow angle of view of 400mm coupled with f/2.8 create an unbeatable package. This gives the photographer control over the background as well as the specific area around the subject. On larger subjects, the slim depth of field can isolate the subject from itself. This combo is what produces many of the great images we enjoy so often in print.

This lens is a killer when used with a teleconverter. Many wildlife photographers use this lens either as a 560mm f/4 (TC-14B) or 800mm f/5.6 (TC-301). The results are magnificent with either which is why these combos are so commonly used. Many use extension tubes with the lens as well. This versatility in the field is what attracts wildlife photographers as they have a lens for low light situations, or one with long reach, all basically in one package.

It is the 400mm f/2.8's narrow angle of view, depth of field, and extreme flexibility and versatility that make this such a marvelous lens to own. This is also why it is seldom available for purchase and why few rental houses stock it.

Nikkor 400mm f/3.5 ED IF

Original release: 1978

Angle of coverage: 6° 10′

Unique features: none Physical size: 5.3"x12"

Weight: 98.9 oz.

Filter size: 39mm screw-in

Lens hood: built-in

M.F.D.: 15'

Aperture range: f/3.5-f/22

The 400mm f/3.5 is a super telephoto whose popularity comes and goes. This is partly because of the 400mm focal length which is a tad too long for sports and a tad too short for wildlife. At least that is the general conception which hasn't stopped some of the top photographers from using it.

It has all the attributes of a typical super telephoto. It has a 122mm dust-proof front plate (accepts 39mm drop-in filters), 360 degree rotatable tripod collar, preset focus click, ED glass and IF focusing. It does have, unlike most super telephotos, minimal shading.

This is a lens that can be found used at a low price relatively easily and is a great way to get into fast super telephotos. It works extremely well with the TC-14B (560mm f/5) and TC-301 (800mm f/7) but vignetting can occur with TC-14A and TC-201.

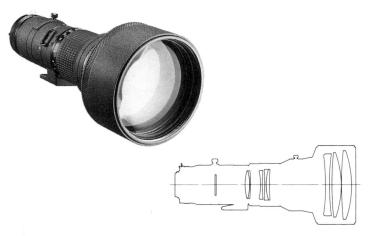

Nikkor 400mm f/3.5 ED IF

Nikkor 400mm f/5.6 ED IF

Original release: 1978 Angle of coverage: 6°10′

Unique features: none Physical size: 3.3"x10.3"

Weight: 42.4 oz.

Filter size: 72mm Lens hood: built-in

M.F.D.: 15'

Aperture range: f/5.6-f/32

At one time "the" lens to own, the 400mm f/5.6 has been left in the dust in terms of speed. It is an extremely sharp, lightweight lens suitable to almost any application in photography.

This lens can easily be handheld with the assistance of a gunstock. In this way, it makes a completely portable system to use in any situation. This also makes it excellent to use with flash since altogether it is a small, portable package. Whether working in a crowd at a race track or in the midst of trees, this portability is a big asset.

Ever need a handholdable 600mm lens? How about one that can focus down to just 15 feet? Well, one can come really close by adding a TC-14B to the 400mm, creating a 560mm f/8. In these days of speed, this combination will not excite many. But wildlife photographers will quickly see the advantage of this used in combination with a flash when chasing small birds in a forest. When working from a canoe in a marsh, this lightweight, close-focusing system is invaluable.

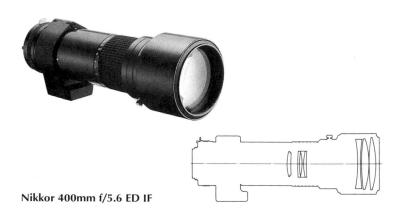

The 400mm f/5.6 is an excellent lens for close-up work. Its light weight allows it to be easily used low to the ground on a tripod. It easily works with large amounts of extension such as Nikon's PN-11, cutting the minimum focusing distance down from 15 feet to just over 7! This extreme amount of extension makes the background a mere wash of color. This, in combination with the narrow angle of view of the lens, isolates the subject like nothing else.

One interesting note, the tripod collar on the AI version is narrower than that of AIS version. Accordingly, the aperture ring on the AI version is wider than the AIS version. Those with big hands or fingers might find this difference significant.

Nikkor 500mm f/4 P ED IF

Original release: 1988 Filter size: 39mm screw-in

Angle of coverage: 5° Lens hood: HK-17

Unique features: "P" chip Physical size: 5.4"x15.5" M.F.D.: 20'

Weight: 105.6 oz. Aperture range: f/4-f/22

If any lens has broken the mold of super telephotos, it is the 500mm f/4 P. It has been a hot lens since the day of its release and not for a moment has it ever looked back!

What immediately attracted so many to this lens is its physical design. The weight of its 122mm dust-proof plate and front element group are balanced out over the entire length of the lens. Since it's relatively short and so well balanced, it does not take a "mega" tripod to give it proper support. It is easy to wheel about when shooting, quickly responding to a fast subject.

For those photographing moving subjects, be it cars, planes or birds, the 500mm f/4 is marvelous for panning. Because of its maneuverability, it can easily be panned. The main thing to remember is to continue to pan even after the exposure to make sure the shutter has completely closed. Anything less and the subject will be out of focus.

What sells this lens is its quality and flexibility. It is razor sharp! This still applies when using a TC-14B (700mm f/5.6) and TC-301 (1000mm f/8) which is extremely common with the lens.

It is also used quite often with an extension tube. Though the lens focuses down to a respectable 20 feet, many use this lens with a PK-12 bringing the minimum focusing distance down to a little over 16 feet.

The 500mm f/4 is a "P" lens. It has an internal CPU which communicates with cameras with matrix metering. This has further endeared the lens with N8008/F-801 users who are left out of matrix metering with nearly all super telephotos within a reasonable price range (reasonable for a super telephoto that is).

The 500mm f/4 has one of the deepest lens shades around. It reverses when in use providing nine inches of shade protection. This is great for the sport photographer who gets plowed into by a football player. For the nature photographer, this extra shade might keep that flinging branch from hitting the front element. Also because it is so deep, shooting backlit subjects is slightly easier, thus opening up other photographic possibilities.

There is one last big selling point of the 500mm f/4, its focal length. If there was such a thing as an ideal focal length for super telephotos, this would be it. For many photographers, 400mm is too short and for others, 600mm too long. The 500mm fits right in between these focal lengths satisfying the needs of the majority of photographers.

Nikkor 600mm f/4 ED IF

Original release: 1979

Angle of coverage: 4° 10′

Lens hood: built-in & HE-5

Unique features: none
Physical size: 7"x18.1"

M.F.D.: 25'

Weight: 222.5 oz. Aperture range: f/4-f/22

This lens captured the imagination of photographers the moment it was introduced. When the lens first arrived, many stores were swamped by those wanting to get a look at it, especially its size. It is still a demigod that many photographers aspire to own. Its allure has to do with its amazing sharpness and an incredible f/4 speed.

This is a big lens! Its 160mm front element was the first to be that large. This is how the lens can gather so much light to be an

Nikkor 600mm f/4D ED IF AF-I

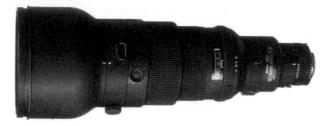

f/4. This also makes it a very bright viewing lens to use, especially in low-light situations. This is where the 600mm f/4's reputation was first grounded as many photographers pushed the limit of available light (in the day of slow ISO films).

This ability started the speed frenzy and overshadowed the lens' ability to isolate the subject. Its staggering 4 degree angle of view translates to 12x magnification of normal vision. It can isolate a subject with very little effort or expertise. Combined with this is its narrow depth of field at f/4. Because of this it was instantly used for photographing sports such as track and field. The lens compacted the action on the field while isolating the subject, making the background a blur.

The lens originally came from Nikon with a TC-14 teleconverter (today it's known as the TC-14B). This makes the lens an 840mm f/5.6. Nikon no longer supplies the teleconverter with the lens but tells of the lens' quality. At 840mm f/5.6, the isolation properties of the lens are enhanced. The angle of view is narrower and the depth of field is reduced by 40%. Nikon's original decision to include the teleconverter is further indication that this super fast telephoto was designed for its isolation powers, not its low-light abilities.

Nikkor 600mm f/4D ED IF AF-I

Original release: 1992

Angle of coverage: 4° 10′ Unique features: internal focus-

driving motor

Physical size: 6.5"x16.4"

Weight: 212.8 oz.

Filter size: 39mm screw-in

Lens hood: HK-18

M.F.D.: 20'

Aperture range: f/4-f/22

This is a remarkable lens! Some photographers were never swept up in the original 600mm f/4 fever, but the AF-I autofocus version changed all that. The original autofocus 600 f/4 never got beyond the glass case that it appeared in at PMA years ago. Nikon must have been biting its tongue ever since with all the criticism coming their way because they did not have a long, fast super telephoto. The time it took to introduce this lens is a perfect example of how conservative a company Nikon really is, not introducing a product until it is right.

One of the more exciting aspects of the lens is it focuses down to just 20 feet - 20 feet, that is remarkable! The manual version focuses down to 25 feet; the 500mm f/4 focuses down to 20 feet but the AF-I focuses as close and is 600mm in magnification. Even more exciting is the 600mm AF-I matches up with a 1.4x (TC-14E) and 2x (TC-20E) teleconverter. This means a photographer can have a 840mm f/5.6 AF or 1200mm f/8 lens that autofocuses down to 20 feet! Awesome!

On the operational side, the 600mm f/4 AF-I is the same as the 300mm and 400mm AF-I lenses (refer to 300 AF-I for complete description). This includes having autofocus lock buttons near the end of the lens. If one has short arms, this can be a drawback as they might be hard to reach and operate. The focusing ring though is slightly smaller but is still quite easy to operate.

One unique cosmetic departure can be seen in the 600mm AF-I. All other super telephotos have straight lines and profile. The 600mm has a rounded, modern look to the front assembly. The later released 400mm f/2.8 AF-I shares this departure from the conservative look of the Nikkor line and might signal a change to come in future designs.

The 600mm f/4 AF-I is probably the quintessential super telephoto of the Nikkor line. Its lightning-fast focusing, combination of narrow angle of view and depth of field, minimum focusing distance, and its flexibility with the teleconverters makes it "the" lens to own. That is, if it fits your style of photography.

The ghostly morgue of Bodie State Park shot with a 35-70 f/2.8 AF, a perfect lens for the vacationing photographer.

Nikkor 600mm f/5.6N ED IF

Original release: 1978 Angle of coverage: 4° 10'

Unique features: none

Physical size: 5.3"x15" Weight: 94.5 oz. Filter size: 39mm screw-in Lens hood: built-in & HE-4

M.F.D.: 20'

Aperture range: f/5.6-f/32

In the race of speed, the 600mm f/5.6 was left in the dust. At least that is the general perception which could not be more unfounded. True it is a f/5.6, but this small, lightweight lens can be extremely fast to use in the field.

It is smaller than the 600mm f/4 . . . lots! It has a 122mm front element and weighs nearly eight pounds less. With the same angle of view as the 600 f/4, it has one stop greater depth of field. It does focus down to just twenty feet though, unlike the 600 f/4 (not to be confused with AF-I) which is at 25 feet. Even with these side-by-side benefits between the two, the 600mm f/5.6 has never had the same following as the 600mm f/4.

The 600mm f/5.6 works marvelously with teleconverters making it very flexible. It also is one of the best super telephotos to use extension tubes with since its minimum focusing distance is already quite short. Many use this combination to photograph wildflowers. Altering the background is a snap and isolating the subject could not be easier. Since the extension tube eliminates any detail in the background, the lens can be closed down to provide the subject maximum depth of field.

This is another super telephoto that can be found used at a reasonable price fairly easily. Do not hesitate to invest in its optics just because it is an f/5.6 lens. Many of the world's top pros use this lens to capture some of our most memorable images, a recommendation not every lens can boast of having.

Nikkor 800mm f/5.6 ED IF

Original release: 1986 Angle of coverage: 3°

Unique features: none

Physical size: 6.4"x21.8"

Weight: 190.8 oz.

Filter size: 52mm screw-in

Lens hood: built-in & HE-3

M.F.D.: 30'

Aperture range: f/5.6-f/32

The 600mm f/4 originally came with the 1.4x teleconverter making it an 840mm f/5.6. I always took this to mean the 800mm f/5.6 was the lens to own. One of the four first telephotos Nikon produced was an 800mm. This was later replaced with the 800mm f/8 (an outstanding lens) and then came the 800mm f/5.6. Like most lenses with an f/stop of f/5.6, the 800 f/5.6 has never been considered fast and so few own it. The small group that does own this lens will tell you though, it is one of Nikon's finest.

It is physically large. The 160mm front assembly does not make the 800 f/5.6 unwieldy as it's well balanced. On a tripod with the proper technique, the lens can easily be used in panning because it is so well balanced. But because of its physical size, some photographers keep from buying it. Its extreme focal length is another factor as few want optics that magnify, for lack of a better word, as much as 800mm (16x magnification).

On the other hand, those who own it shoot with it for just that reason. The 800mm f/5.6 has a tremendous isolation ability. True, other lenses can be made into 800mm's with teleconverters, but there seems to be a marked difference in isolation ability between the straight 800mm and a converted 800mm. This could be why some of the top wildlife photographers in the world own and religiously use the 800mm f/5.6 over other combos for their super telephoto needs.

The minimum focusing distance on the 800mm is pretty good at thirty feet. But for small subjects this is still too far. Many use a simple PK-11a tube which brings the minimum focusing distance down to less than 27 feet. There are a number of photographers who almost always have teleconverters married to their 800mm. The 1.4x is the most common, but there are a number of 1600mm f/11s in use. Either combination is a killer which is why it is so widely used.

The optics of the 800 f/5.6 are some of the finest Nikon produces. But because of its speed, few have ever enjoyed its incredible imagery. That is probably just fine with those who own and use the 800mm daily. As was stated earlier, the lens is what dictates the style of a photographer. Many would be surprised just how many of the great images where taken with the 800mm f/5.6 and how important a roll it plays in the success of the photograph.

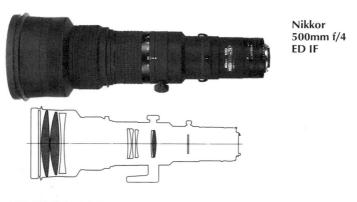

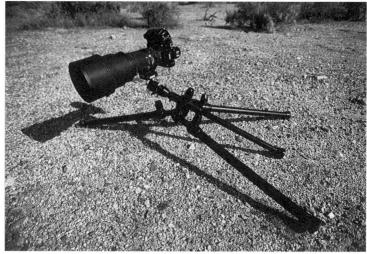

No other tripod in the world can perform the contortions that a Benbo can! It is the most versatile tripod I have ever used.

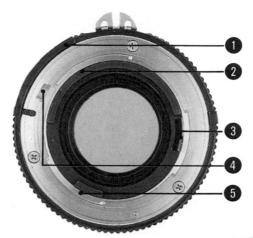

Al S Bayonet Mount

- 1. Meter coupling ridge
- 2. Protective collar
- 3. Auto aperture coupling device
- 4. Focal length identification notch
- 5. Aperture indexing post

- 6. AI S Meter coupling
- 7. Focal length indicator
- 8. Aperture stopdown lever
- 9. Lens mounting flange
- 10. F bayonet mount flange

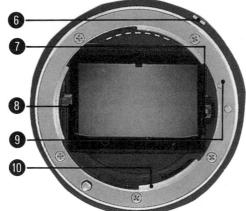

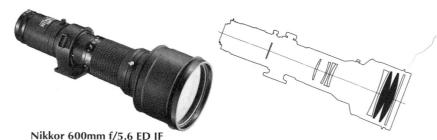

Zooms

Tricks of the Trade

No group of lenses has been more misunderstood or maligned than zooms. The original zooms of the early 1960s and the noise of the original autofocus zooms, gave zooms a stigmatism that has been hard to shake. However, if the current line of zooms does not finally convince photographers of the quality and creativity these lenses offer, nothing will!

A zoom lens can replace a number of prime focal length lenses within its single range. For example the 75-300mm f/4.5-5.6 AF incorporates the prime focal lengths of 85mm, 105mm, 135mm, 180mm, 200mm and 300mm. This extreme versatility and flexibility is what makes the zoom such a powerful, creative tool for the photographer. It makes zooms very economical to own as well, eliminating the need to purchase all of those prime lenses separately.

Using a zoom requires an observant photographer. Like ultra wides, zooms can capture unwanted elements. But unlike the ultra wide, the zoom can simply be zoomed in or out to eliminate the unwanted objects. However, when using a zoom on a body that provides only 92% viewing, this is easier said than done as not all of the image that is captured on film is seen. With these cameras, zooming wider to see and discover any unwanted elements, then zooming back to eliminate them is the way to maximize their flexibility.

Variable f/stop Design

One of the biggest "knocks" of zooms is their variable f/stop design. This comes from old school photographers still demanding complete control over shutter speed and f/stop. Since the lens changes its effective f/stop when zoomed (where this occurs in the zoom range is provided in the tech sheet that accompanies the lens), they have a hard time being in control of the exact f/stop. Those, on the other hand, who take advantage of any of the camera's program modes (and their stepless shutter speeds)

could care less as they know they are taking advantage of both worlds in photography while maintaining complete control.

That variable f/stop design is very important in today's zoom lens design. It is what allows the small, compact design that so many photographers enjoy. A good example of this is the 35-70. The variable f/stop version is only two inches long and has a 52mm front element. The constant f/stop version is four inches long and has a 62mm front element. The constant f/stop version also has a nearly 300% higher price tag!

Zooms naturally lend themselves to being handheld. This requires proper technique to maximize image sharpness. Some zooms though, add a twist to this by having two rings rather than one. The focusing and zooming action can still be controlled by the left hand, but care must be taken to prevent knocking the zoom from its desired setting. This simply requires practice.

Macro Plus Versatility

Almost every zoom has a macro feature. Some of these are at a particular focal length and others are throughout the entire zoom range. This provides an added degree of flexibility to an already extremely versatile lens. This can be enhanced by extension tubes or auxiliary close-up attachments such as Nikon's 3T, 4T, 5T, or 6T. None of these options affect image quality nor will the zoom function differently with their addition.

Zooms allow photographers to carry all the focal lengths they might require in just a couple of lenses. For example, an excellent combo I highly recommend is the 24-50mm f/3.5-4.5 AF and 75-300mm f/4.5-5.6. Both of these lenses have the same front element size so only one set of filters is needed. Both lenses have autofocus technology and will interface with any body with matrix metering. Also both lenses offer optical quality that is hard to match! These two lenses in a vest pocket along with a super telephoto could support any nature photographer's habit for a lifetime.

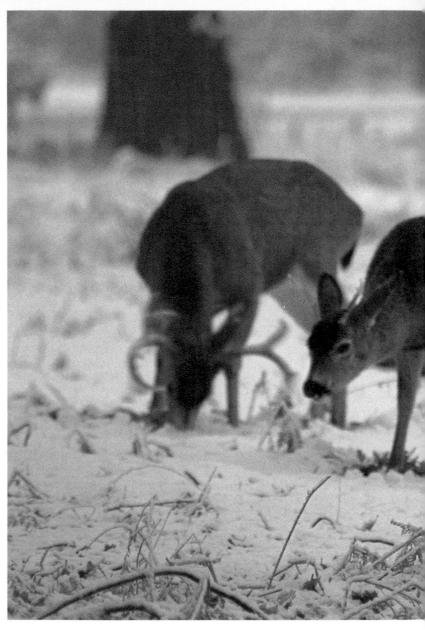

Mule Deer on a crisp, overcast day, shot with the 24-50mm f/3.5-4.5 AF set at 35mm.

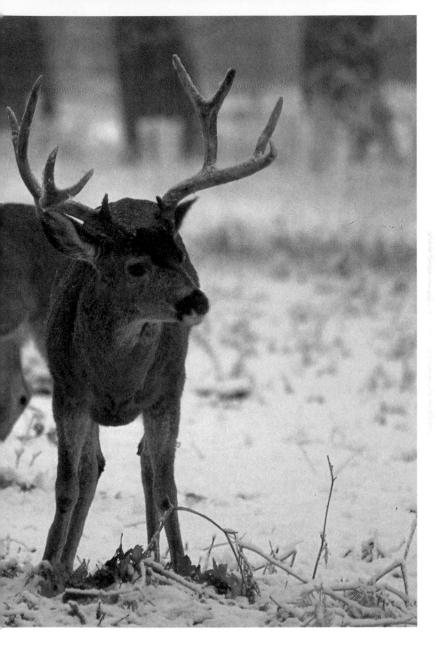

Nikkor 20-35mm f/2.8D AF

Original release: 1993 Angle of coverage: 94-64° Unique features: none

Unique features: none **Physical size:** 3.3"x3.7"

Weight: 20.6 oz.

Filter size: 77mm Lens hood: HB-8

M.F.D.: 1.7'

Aperture range: f/2.8-f/22

What an awesome range! A long awaited zoom that is definitely well worth the wait. Incorporating what is probably a photojournalist's most used set of focal lengths, this lens is definitely geared towards their style of photography.

The 20-35 incorporates "D" technology which will interface completely with the flash technology of the N90/F90. This allows the photojournalist to have the flexibility to use this lens in com-

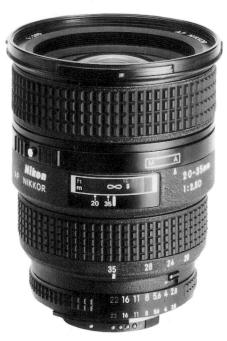

Nikkor 20-35mm f/2.8D AF

bination with the N90/F90 for "over the head" shots. This is where the photojournalist simply holds the camera over his or her head and fires away. The camera will take care of focus and flash exposure, increasing the odds of obtaining the shot.

The quality of the optics is apparent even when just viewing through the lens. Its bright image is magnificent, making working in low light levels easier. It also has less barrel distortion than the 35-70mm f/2.8(which is minimal already). Of course, it is on the light table that its real brilliance shines, revealing remarkably sharp images.

Scenic photographers are probably a little disappointed in the 20-35 because of its filter size. The 77mm size is an odd ball in the Nikon scheme, requiring a set of filters for just this one lens. The large angle of view at 20mm also means that stacking filters is out of the question. This is one lens which is a perfect candidate for having color correction filters attached at the rear. The large filter size also eliminates the option of using Nikon's auxiliary close-up filters.

The lens is physically large and heavy compared to other zooms. Its price is also 300% higher than other zooms. These factors in combination with some of its limitations for general photographers might limit its appeal. It is also a two ring lens, one ring zooms and the other focuses. As with many of Nikon's lenses, this means a small group will own this lens and create the images while the rest will wonder how they were taken.

Nikkor 24-50mm f/3.5-4.5 AF

Original release: 1988

Angle of coverage: 84-46°

Unique features: macro mode Physical size: 2.8"x3.2"

Weight: 13.2 oz.

Filter size: 62mm

Lens hood: HB-3

M.F.D.: 1.6'

Aperture range: f/3.3-f/22

The 24-50 f/3.5-4.5 was released at a time when faith in Nikon's autofocus system was in question. The variable f/stop design was instantly pooh-poohed but its optics quickly turned everything around. This is probably why this lens is still produced, has never been changed, and is a favorite world-wide.

The lens covers a choice, comfortable range of 24-50mm which is what attracts most photographers to the it. It is also physically small and light which makes it a natural for travel photography. It accepts the Nikon 62mm polarizer with no vignetting. This makes this lens, all in all, a real standout!

Since so many photographers own this lens, it has been applied to every aspect of photography. It is a good lens for general photography and is often used on remote cameras. It is guite

Nikkor 24-50mm f/3.5-4.5 AF

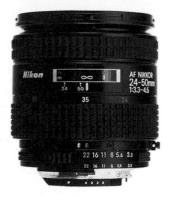

often used in its macro mode which produces a 1:4 magnification. Extension tubes are frequently added to the lens; a PK-11a makes possible a magnification of 1:2. And the most popular thing is the addition of Nikon's auxiliary close-up lenses, 5T and 6T. This zoom is not a "flat field" lens by design. Yet in all these altered versions, the image quality is remarkable.

Its zooming and focusing are performed by two separate rings, or what is called a "two-touch" lens. It is this tremendous range of flexibility that will always make the 24-50 one of the most popular lenses in the Nikon system.

Nikkor 28-70mm f/3.5-4.5D AF

Original release: 1993 Filter size: 52mm Angle of coverage: 74-34° 20′ Lens hood: HB-6

Unique features: aspherical element

Physical size: 2.7"x2.8" M.F.D.: 1.3

Weight: 12.4 oz. Aperture range: f/3.5-f/22

Ever wonder why with 35-70s and 28-85s Nikon would introduce a small 28-70mm f/3.5-4.5? The lens is intended for the casual photographer who shoots with a camera with built-in flash. Larger lenses tend to cause cut-off of the camera's in-board flash, creating a dark line in the photograph. This is especially the case with any type of close-up work. The small size of the 28-70 eliminates this problem which is why it was added to the Nikon system.

Nikkor 28-70mm f/3.5-4.5D AF

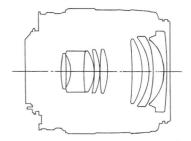

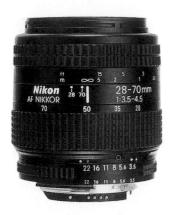

Wonder how they made the lens so small? The 28-70 has an aspherical element which is not usually found in zoom designs. This enables the lens to be physically small, yet render tremendous sharpness. It also makes the lens very bright and clear to focus even in low-light levels.

The one drawback is that the focal length is generally not popular with "serious amateurs" or pros. Another is that it is a "two-touch" lens, two ring zoom and focus operation. This is what keeps the lens from being widely used but it was not designed with that in mind. It is an excellent example of Nikon's commitment to produce optics that fit a specific requirement, filling every photographer's needs.

Nikkor 28-85mm f/3.5-4.5N AF

Original release: 1992

Angle of coverage: 74-28° 30'

Unique features: macro mode

Physical size: 2.8"x3.5"

Weight: 18.9 oz.

Filter size: 62mm

Lens hood: HB-6

M.F.D.: 0.8'

Aperture range: f/3.5-f/22

One of the more popular focal length arrangements for a zoom, the 28-85 and photographers have had a love/hate relationship. The original 28-85 AF had a very narrow focusing ring and was perceived as not being tack sharp. The 28-85N changed that per-

Nikkor 28-85mm f/3.5-4.5N AF

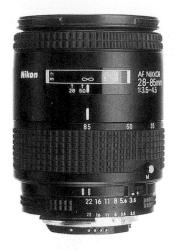

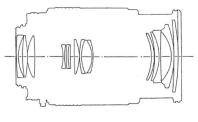

ception, going on to be widely owned. A big part of its popularity is its tremendous flexibility. Its zoom range fits a very comfortable range of 28-85. This is a range commonly owned in prime focal lengths by the majority of travel photographers. It also has an excellent macro mode with a minimum focusing distance of 0.8 feet providing a little better than 1:4 magnification.

Its filter size is now the very common size of 62mm (not so when first released). The 28mm is not so wide permitting the use of stacked filters without the worry of vignetting. This is appreciated by the owners of the lens who are usually casual shooters.

The price of the lens is targeted at this same group, still there is no sacrifice in quality. This is by far one of the nicer zooms, delivering superb image quality throughout its zoom range with excellent edge-to-edge sharpness. Its two ring zoom and focus operation has never seemed to hurt its popularity. It is all these reasons wrapped up in a small package that makes the 28-85N such a popular lens.

Domke's F-4AF "Pro System" Bag is designed to accommodate a variety of autofocus systems.

Nikkor 35-70mm f/2.8D AF

Original release: 1992

Angle of coverage: 62-34°20′ Unique features: macro mode

Physical size: 2.8"x3.7"

Weight: 23.5 oz.

Filter size: 62mm

Lens hood: HB-1

M.F.D.: 0.9'

Aperture range: f/2.8-f/22

The 35-70mm f/2.8 was one of the original autofocus lenses to be released. It is one of the few that was instantly accepted and has

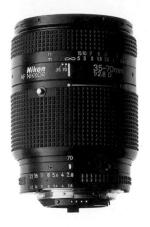

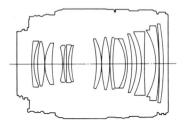

never been modified since its introduction (except for "D" conversion). Although for many this is a dull and limited range, the 35-70 is extremely popular with those in the press. Its constant f/stop is what has caught the attention of other photographers. And from this, word of mouth has made it one of the more popular autofocus lenses.

Page 129:

Let the water flow from horizon to foreground with the 20mm f/2.8 AF and give it life with a slow shutter speed of 4 seconds.

Page 130:

The magnificent vista of Bryce's main amphitheater is given air to breath in the frame by using a 20mm f/2.8 AF.

Page 132, top:

The low angle and wide vista of the 20mm f/2.8 AF captures a part of the main street in the old ghost town of Bodie.

Page 132, bottom:

Capturing the romance of the ghost town of Bodie required a 75-300mm f/4.5-5.6 along with 81a, graduated and polarizing filters.

Page 133, top:

This headlight of a junkyard truck takes on new light when highlighted by the 60mm f/2.8 AF Micro.

Page 133, bottom:

The sun setting on an old barn in the ghost town of Bodie is captured by the 35-70mm f/2.8 AF. The barn itself has stood for years in this same condition.

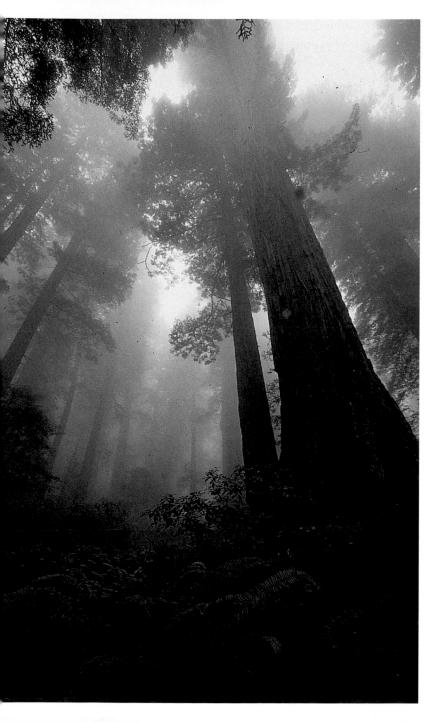

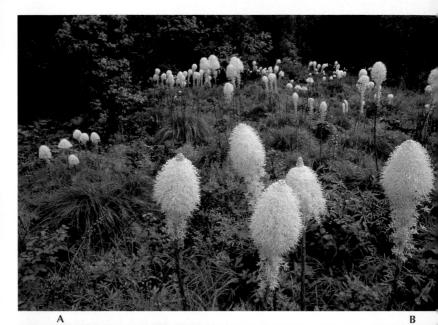

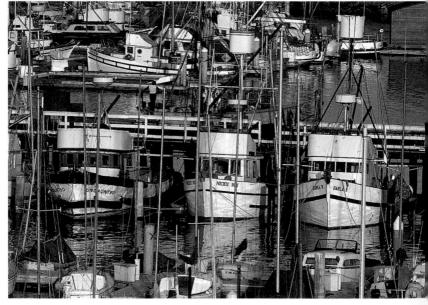

The 35-70mm f/2.8's sharpness from corner to corner adds to the versatility of this zoom. It is a push-pull zoom with 35mm being at the end of the push. This is where the lens must be set to use the macro mode (35mm focal length only). It has the ability to achieve 1:4 magnification at this setting and with the addition of a PK-11a extension tube or 6T filter, the lens can reach nearly 1:1 magnification. It provides a free working distance of approximately seven inches in this mode. Even in this application, the lens still performs magnificently.

Physically, the 35-70 f/2.8 is big, as much as 300% larger than other versions. Its price tag is just as inflated, but even so, the lens is extremely popular. This is due in part because it is a push-pull zoom rather than a two ring affair. It is also due to its fitting into a basic system of 20mm f/2.8 AF, 35-70mm f/2.8D AF and 75-300mm f/4.5-5.6 AF. All with the same filter size, these three lenses provide coverage of a tremendous range with the best lens quality available.

Page 134, top:

Shooting the delicate formation of Yellowstone's Mammoth Hot Springs is complicated by having to keep a safe distance from the hot water; a job best done with the 75-300mm f/4.5-5.6 at 250mm.

Page 134, bottom:

The grand view of Yosemite Valley from Glacier Point can only be taken in with the eye of the 13mm f/5.6.

Page 135:

The wide world of the 15mm f/3.5 isn't even wide enough for the towering coastal redwoods.

Page 136, top:

What appears to be popcorn on a stick is really bear grass in the Montana Rockies captured by a 20mm f/2.8 AF.

Page 136, bottom:

The fleet's in, but isolating the boats from all of the activity requires the isolating power of the 300mm f/2.8 N AF.

Nikkor 35-80mm f/4.5-5.6D AF

Original release: 1993

Angle of coverage: 62-30°10′ Unique features: macro mode

Physical size: 2.6"x2.4"

Weight: 9 oz.

Filter size: 52mm Lens hood: HN-2

M.F.D.: 1.15'

Aperture range: f/4-f/22

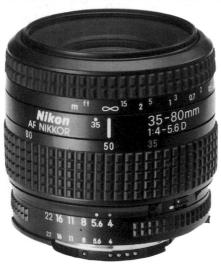

At the writing of this book, this lens had just been announced and had not yet been used by the author. Its performance is unknown therefore and possible applications could only be extrapolated from other lenses of the same focal length. One interesting piece of trivia regarding this lens is that it is manufactured at Nikon's Thailand plant.

Nikkor 35-80mm f/4.5-5.6D AF

Nikkor 35-105mm f/3.5-4.5N AF

Original release: 1991

Angle of coverage: 62.23° 20′

Unique features: macro mode

Physical size: 2.7"x3.4"

Weight: 16.1 oz.

Filter size: 52mm Lens hood: HB-7

M.F.D.: 1.3'

Aperture range: f/3.5-22

The 35-105 has always been a popular focal length with general shooters. Family photographers especially like this focal length which is great for group shots as well as individual portraits. Its small size and price has only enhanced its popularity. The rede-

Nikkor 35-105mm f/3.5-4.5N AF

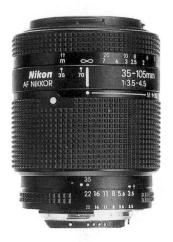

sign of cosmetics with this current version placed many of the original design on the used lens shelf making them an excellent first zoom purchase.

The "N" version's biggest improvement is in its response. The zoom has a push-pull action while the original version had a two ring operation. At the end of the zoom collar is the focusing ring which travels with the collar when zooming. This makes for fast reaction time to focusing when zooming.

The lens has a macro mode with a maximum of 1:3.5 magnification (105mm focal length only). It has an excellent free working distance lending itself to macro work. The addition of Nikon's three extension tubes, PK-11a, PK-12 and PK-13 achieves a little better than 1:1 magnification while the lens delivers marvelous quality. This is probably why this is a lens commonly found in the nature photographer's bag.

Nikkor 35-135mm f/3.3-4.5N AF

Original release: 1989

Angle of coverage: 62-18°

Unique features: macro mode Physical size: 2.7"x4.4"

Weight: 23 oz.

Filter size: 62mm Lens hood: HB-1

M.F.D.: 1.2'

Aperture range: f/3.5-f/22

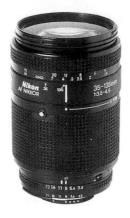

The 35-135 is really just a big brother of the 35-105. It provides a slightly longer zoom and is accordingly, slightly larger physically with a 62mm front element. It too has always been popular with the family photographer, but has never really gotten past that spot.

The 35-135 got a boost in popularity with the "N" version's push-pull design. The original was known as a "two-touch" or two ring zoom. This makes for very slow response time when baby is taking his or her first steps. The "N" version has the focus ring as part of the zoom collar, so the actions are always together and quite quick to use.

Its performance closely resembles that of the 35-105 and can be manipulated much in the same way. Though its overall quality is satisfactory, it is not stunning. Its performance, when used with extension tubes is not as good in the corners as that of the 35-105. Its macro mode is at the 135mm setting only.

Nikkor 35-200mm f/3.5-4.5

Original release: 1986

Angle of coverage: 62-12° 20′ Unique features: macro mode

Physical size: 2.7"x5"

Weight: 25.9 oz.

Filter size: 62mm Lens hood: HK-15

M.F.D.: 1'

Aperture range: f/3.5-f/22

Lost in the conversion to autofocus systems is the 35-200. This remarkable lens was one of the first zooms to be introduced with variable f/stops. This was at a time when manual everything was so big that this lens never really caught on. This is a loss to photographers since it delivers extremely sharp images in a small. compact, and easy to use push-pull zoom.

Like many zooms, it has a macro mode delivering 1:4 magnification. This can easily be increased with the use of extension tubes delivering excellent edge-to-edge quality. It can be further enhanced with Nikon's close-up lenses, 5T and 6T. Because of its small size, it can be easily handheld lending itself to many applications where a larger 200mm lens would be difficult. This includes macro subjects. It has no tripod mount, but because the lens is small it can be attached to the body, providing amazing results with little effort.

With the upgrading of many photographer's systems to autofocus, the 35-200 can often be found on the used lens shelf. With the exception of its slower lens speed, it has a greater range and smaller size than the 80-200 f/2.8 AF. Its filter size is also smaller. 62mm, fitting the norm for most of the current autofocus lenses. It is one of the best examples of a great lens being passed by because of speed rather than performance.

Filter size: 62mm

Lens hood: HN-24

Nikkor 70-210mm f/4-5.6D AF

Original release: 1993

Angle of coverage: 34°20′-11°50′ Unique features: macro mode

Physical size: 2.8"x4.5" M.F.D .: 4' Weight: 20.6 oz.

Aperture range: f/4-f/32

One of the first autofocus lenses to be introduced, the 70-210 has gone through a number of changes. The "N" version represented cosmetic, operational (push-pull) and optical changes improving its overall performance. The "D" is an identical lens to the 70-210N, with the addition of the "D" technology. Its small, compact size, ease of use and economical price, make it extremely popular. The change from a fixed f/4 to a variable f/stop is what made it smaller in size

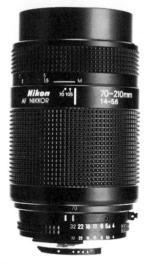

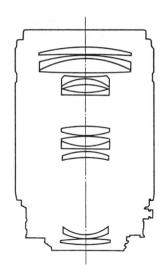

Nikkor 70-210mm f/4-5.6D AF

All versions of this lens have excellent sharpness. This is especially true in the corners which is not typical for zooms. It has a macro mode providing a 1:4.5 magnification, not earth shattering. Trying to use extension tubes to extend this range has minimal results as far as increasing magnification, but there is no optical loss. Using Nikon's close-up attachments, 5T and 6T work great though.

If there is a drawback to this lens, it is its zoom range. Other lenses now incorporate this range and speed in their design somewhat passing by the 70-210. This is by no means a reflection of the lens' quality just a natural state in photography as more versatile optics are introduced.

Nikkor 75-300mm f/4.5-5.6

Original release: 1989

Angle of coverage: 31°40′ - 8°10′

Unique features: macro mode

Physical size: 2.6"x6.8"

Weight: 30 oz.

Filter size: 62mm Lens hood: HN-24

M.F.D.: 5'

Aperture range: f/4.5-f/32

Nikkor 75-300mm f/4.5-5.6

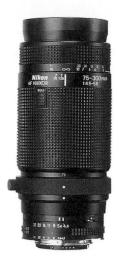

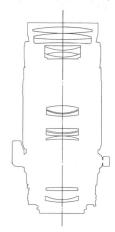

This is an amazing lens that has a home in many nature photographers' camera bags. There are a number of reasons for this but it comes down to one theme: amazing versatility with excellent to outstanding optics at a very economical price.

Its range is also excellent providing a lot of reach in a small package. At the 300mm setting it is an f/5.6 which is slow. But it is small which makes handholding at this range easy. The lens incorporates a tripod collar which has endeared it to most of its owners. The collar though, is not like those found on the super telephotos. Because of this, using it requires practicing long lens techniques (refer to the previous chapter). Using the lens mounted to tripod remotely, can result in less than satisfactory images because of the weak tripod collar.

The lens' macro mode allows it to focus down to five feet. This holds true through the entire zoom range which makes it one of the closest focusing 300mm lenses. For photographing subjects such as a rattlesnake, this is nice, but it is also great for nesting birds or people pictures. The lens readily accepts and works magnificently with extension tubes, increasing its versatility.

Its autofocus speed is about as fast as its f/stop. To help increase the autofocus speed, it has a limit switch but it really has a minimal effect. The focusing of the lens is probably its only drawback. With the focusing ring at the end of the lens near the

filter ring, when the lens is zoomed out to 300mm, this makes it difficult for some to properly handhold it.

The 75-300's 62mm filter size makes it perfect for scenic work. Since there are so many filters such as polarizer and graduated split neutral density available in this size, the zoom is a natural. This is especially true at the 300mm range as other 300mm lenses have 72mm or larger front elements.

Nikkor 80-200mm f/2.8D ED AF

Original release: 1992 Filter size: 77mm Angle of coverage: 30°10′ - 12°20′ Lens hood: HB-7

Unique features: macro mode

Physical size: 3.4"x7.3" **M.F.D.:** 4.9'

Weight: 42.3 oz. Aperture range: f/2.8-f/22

This is one meaty lens! Its large size reflects the lens' speed which is a blistering f/2.8. The optical design which incorporates ED glass makes it one of the finest performing zooms on the market. Made with the photojournalist or available light photographer in mind, the 80-200 has found a home in thousands of photographers' bags.

Its fast f/stop provides it a shallow depth of field. Many indoor sports photographers prefer this lens just for that reason. This holds true for fashion-runway photographers and wildlife photographers. Its extreme clarity while wide open makes it a marvelous tool for isolating subjects.

The one controversy or complaint about the 80-200 is that it has no tripod mount. Because of its size and weight, using the lens on a tripod, especially vertically, is difficult at best. The addition of a tripod mount would have made the lens much bigger physically and it would have cost more (its predecessor did have a tripod collar and no one bought it because it was so big). Like many optics, the design reflects trade-offs in order to produce the best possible lens. *Kirk Enterprises* makes a tripod collar for the 80-200 which is extremely popular, solving the problem of using the lens on a tripod.

But because of the lack of a tripod collar, the 80-200 is quite often matched up against the 75-300. Both lenses are outstanding

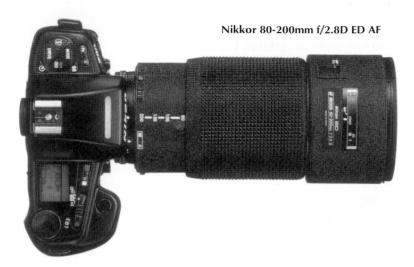

and comparisons should take into account other factors, mostly their photographic application. The 75-300 is more versatile while the 80-200 can isolate better. Both are excellent choices depending on your photographic needs.

Nikkor 50-300mm f/4.5 ED

Original release: 1965

Angle of coverage: 46-8°10′

Unique features: ED glass

Physical size: 3.9"x9.7"

Weight: 68.9 oz.

Filter size: 95mm Lens hood: HK-5

M.F.D.: 8.5'

Aperture range: f/4.5-f/32

A throw back to the beginnings of Nikon, the 50-300mm f/4.5 had the greatest zoom range of its day. A big lens, its zoom is a two ring affair. One ring zooms while the second focuses. Its moderate f/stop and great range create a large package which few can handhold. Its optical design and ED glass make it an amazingly sharp lens at any focal length.

With filtration limited at the front, many tape filters to the rear. This is the only limitation to this lens' versatility. It probably is owned by very few, though, despite its quality and versatility. It is used mostly by nature and wildlife photographers who enjoy its

zoom range and very bright image. It is particularly well-suited for working from a blind where its zoom range becomes quite handy.

The earlier versions of this lens can be found used with little effort. Of all the versions, this is probably the best, but one should not hesitate to buy an older one. Since it is relatively low-priced, this lens is a great help in determining which focal length fits ones style of photography. It is also great for remote work if there is any concern over the lens' welfare. Because of its size and weight, wind has very little effect on it which is another bonus when using it remotely.

This is a lens you'll rarely see in use. Those who do own it though are very loyal and have remarkable images to substantiate its performance. This is probably why in this day and age of speed and autofocus, the lens is still available from Nikon.

Filter size: 95mm

Lens hood: HN-16

Nikkor 180-600mm f/8 ED

Original release: 1974

Angle of coverage: 13°40′ - 4°10′

Unique features:

Physical size: 4.1"x16" **M.F.D.:** 8.5'

Weight: 126.9 oz. Aperture range: f/8-f/32

The 180-600mm is the super telephoto of the zoom world (there was a 360-1200, but it is now discontinued). Physically long, it is surprisingly easy to use because of its narrow profile. It is basically 95mm or smaller in diameter throughout the entire length of the lens, lending itself to many applications where larger lenses would be inappropriate.

It has never caught on in popularity because of its speed and price. It is an old design which is reflected in its size and speed. While it seems like a perfect lens for wildlife photography, few are in the field because focusing it is slow. Four handles can be attached to the massive zoom collar (it is a push-pull zoom) which is also the focusing ring. These handles are attached to facilitate speed in focusing. A substantial degree of turning must be done to focus on a subject at varying distances. Since this is slow, many images are lost in the process.

There are photographers out there successfully using this lens though. Its incredible zoom range and tack-sharp images are hard to argue with once you've become fully comfortable manipulating it. For 99% of the photographers, it is forever tripod bound. But one photographer I know is very proficient in using the lens on a gunstock.

One of the very surprising attributes which has always attracted me to this lens is its minimum focusing distance. At 600mm, it is 8.5 feet! No other 600mm lens can do that and in itself, I would think that would attract many buyers. When working from a blind for example, this lens can get photographs that no other lens made could.

Specialty Lenses

Tricks of the Trade

This very specialized group of lenses has only one thing in common. Each is designed to fill a particular and unique niche in photography. Where other groups of focal lengths might have generalized tricks of the trade, that is not the case for these lenses.

Since these lenses are so specialized, each lens' unique features and designs will be discussed. Some of the features and design attributes of other lenses of the same focal length may apply, so reading about similar lenses in the other chapters will be helpful. But most are specific to the particular lens which is why they are specialty lenses!

Nikkor 58mm f/1.2 Noct

Original release: 1978 Filter size: 52mm Angle of coverage: 40° 15′ Lens hood: HS-7

Unique features: aspherical lens

Physical size: 2.9"x2.5" **M.F.D.:** 1.7'

Weight: 16.4 oz. Aperture range: f/1.2-f/16

"This lens was specially designed for photography at night and in poor light." This quote from Nikon's dealer catalog cuts right to the core for the 58mm f/1.2 Noct. This lens was never intended for the general photographic public and it has never been widely owned because of its price. All this adds up to making this lens one of the demigods of the Nikon system.

It is sharp! The "improved optical system provides virtually distortion-free performance down to the closest focusing distance of 1.7 ft. (0.5m) as well as high-contrast images." The higher contrast of the lens enhances the perceived sharpness of the "Noct." Though the lens is already sharp, this increase in contrast over the normal Nikkor lens makes its images really pop.

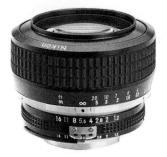

What really makes the Noct a unique, special application lens is its aspherical front element. It "assures optimum correction for coma, particularly at maximum aperture, thus making bright point sources of light near the edges of the picture frame appear as dots rather than comet-shaped blurs." Folks such as astronomers hook this lens to their telescopes for photography because the stars (point sources) will be recorded accurately so any comet-shaped light might be just that, a comet.

What's amazing is that all of this is wrapped up in a lens that has a 52mm front element. The majority of speedy lenses have a large front element which is not the case here. The surprises in this small package are many. This includes the other uses that Nikon points out, "Can be used for any subject, such as candids, travel photography, sports and weddings."

Nikkor 60mm f/2.8 Micro AF

Original release: 1989 Angle of coverage: 39° 40′

Unique features: focuses 1:1

Physical size: 2.5"x2.9"

Physical size: 2.5 x2.9

Weight: 16 oz.

Filter size: 62mm

Lens hood: HN-23

M.F.D.: 8.75"

Aperture range: f/2.8-f/32

One of the first lenses Nikon ever manufactured was a micro. The 60mm f/2.8 AF carries on Nikon's commitment to this specialized lens and its quest to out perform itself. All previous micros in this range have had a focal length of 55mm, prior to the 60mm. They could only reach the magnification of 1:1 with the addition of an extension tube (matched PK-13). The 60mm micro departs from

This close portrait of the endangered Coachella Fringe-toed Lizard was taken with a 60 mm f/2.8 Micro.

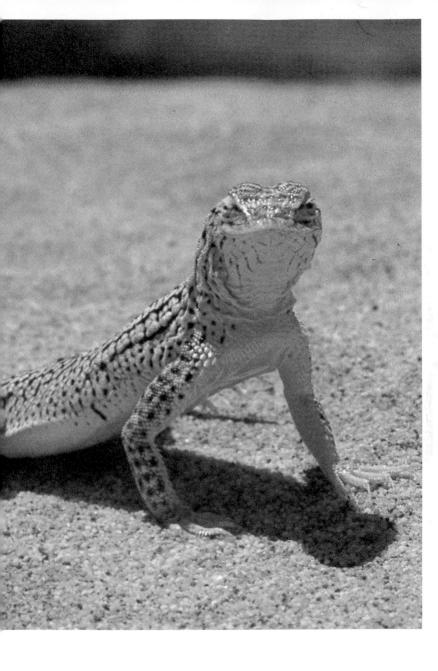

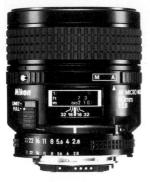

Nikkor 60mm f/2.8 Micro AF

tradition in that it is able to go 1:1 without any tubes. It carries on the high standards of previous micros in sharpness and performance.

The 1:1 magnification is accomplished by an internal rearrangement of the element array. The elements physically move and change their relationship to each other with the addition of air gaps. In this way, the lens does not require adding extension to the rear of the lens to achieve this magnification as it is accomplished internally. This translates into only loosing 1-2/3 stops when at 1:1 rather than the expected 2 stops. The free working distance at 1:1 is approximately 3.75 inches.

The lens' autofocus isn't quick. The autofocus operation involves not only engaging it at the body, but on the lens as well. There is a ring with a lock button which must be depressed before turning to engage the autofocus. To improve on its autofocus ability, Nikon has included a limit switch to prevent the lens from searching for focus from infinity to its minimum focusing distance. The switch can be set to limit focusing within two zones, one foot to infinity and 8.75 inches to one foot. When the switch is on full, the full range of focusing is available. This switch affects both manual and autofocus operation.

Autofocus is not the most appropriate tool for shooting macro because the AF sensor is dead center. Many times the lens will have to search to find a focus point, and what it finds is often not the spot you had in mind. Macro focus is still better accomplished manually unless you are using the N90/F90. Remember that depth of field when working macro is very limited, your focus better be right-on to make the most of what you have got.

The 60mm has a depth of field distance scale for f/16 and f/32. Since f/32 means the lens is completely closed down (not recommended in most instances because of refraction) and f/16 generally does not offer enough depth of field for most 1:1 subjects, the DOF chart leaves too much to the imagination. Most photographers shoot at f/22 and so devise their own DOF chart to work with the 60mm. This can either be on a label placed on the lens or a chart that is held next to the lens barrel.

All of the legendary 55mm micros that proceeded the 60mm incorporated Nikon's CRC technology. The 60mm does not, it achieves its tremendous edge-to-edge sharpness through the realignment of elements. This is probably the biggest departure from tradition for the 60mm and why it will probably be the most popular micro ever.

One other note, this lens works great at infinity as well. Do not pigeon hole this lens as just a micro, you will not be getting your money's worth out of it!

Nikkor 105mm f/2.8 Micro AF

Original release: 1990 Filter size: 52mm
Angle of coverage: 39° 40′ Lens hood: HS-7

Angle of coverage: 39° 40′.
Unique features: focuses 1:1

Physical size: 2.8"x3.7" **M.F.D.:** 1.2'

Weight: 21.3 oz. Aperture range: f/2.8-f/32

Like the 60mm, the 105mm f/2.8 comes from a long line of micros. Beginning with the 105mm f/4 Bellows lens, this current generation 105mm is by far the best. This is because it is able to focus 1:1 without extension tubes and because of its incredible image quality.

The 105mm f/2.8 employs the realigning element technology of the 60mm. In this way, the lens can focus 1:1 without the addition of 105mm of extension. This translates into not loosing the normal two stops of light at 1:1, but having an effective f/stop of f/5 (1-2/3 stops). The free working distance at 1:1 is approxi-

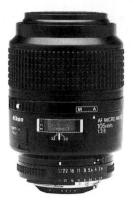

Nikkor 105mm f/2.8 Micro AF

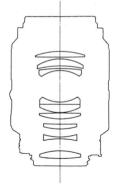

mately seven inches, less than the manual version but almost twice that of the 60mm.

This free working distance is the biggest factor one should consider when deciding which macro lens to buy. This distance is important because of two factors: required distance from the subject and the use of auxiliary lights. Shy or dangerous subjects require this extra distance for their and your own safety. Adding flash or reflectors for lighting which is common, can be a lot simpler with the extra free working distance. Trying to jam them in place when using the 60mm does not work well.

The 105mm is also a magnificent portrait lens, a testament to its tremendous flexibility. It can focus manually or automatically from 1:1 to infinity and it has a two-zone limit switch, same as the 60mm micro, to speed up autofocus operation.

If there is a drawback to its design, it is that its filter size is 52mm. As so many lenses are currently 62mm, this throw-back to early Nikon means carrying either a second set of filters or a step up ring. Neither is a great alternative.

Nikkor 105mm f/4.5 UV

Original release: 1988 Filter size: 52mm
Angle of coverage: 23° 20′ Lens hood: none

Unique features: records UV

band of light

Physical size: 2.7"x4.6" M.F.D.: 1.57' Weight: 18 oz. Aperture range: f/4.5-f/32

In the dictionary under "special application lens" is a photograph of the 105mm f/4.5 UV. This lens probably wins the least known, least owned prize because its use is so very specialized. It looks a lot like the 105mm f/2.8 micro (manual version), but its similarity to normal camera optics ends there.

"UV rays are electromagnetic waves around 200-400nm. The human eye is sensitive only within a range of 380-780nm, though it is possible to get valuable information from UV photography which the human eye cannot catch, particularly in fields as medical and forensic science, criminal lab work, and examination of fine art and industrial works." This is how the lens is depicted in the Nikon dealer catalog, summing up the purpose of the lens quite thoroughly.

This is not a lens you'll find on your neighborhood dealer's shelf as it is a special order item. As you might detect from its description, it was not designed for the average photographer. It's the best example of Nikon's continuing commitment to manufacture optics for the scientific community. If you were wondering, it is not a micro lens. Its minimum focusing distance is 1.57 feet.

Nikkor 120mm f/4 IF Medical

Original release: 1981

Angle of coverage: 18° 50′

Unique features: built-in ring light

Physical size: 3.9"x5.9"

Weight: 62 oz.

Filter size: 49mm

Lens hood: none

M.F.D.: 4'

Aperture range: f/4-f/32

Nikon throughout its manufacturing history has made optics with specific scientific applications. The Medical Nikkor lens series is a good example of this. The 120mm f/4 IF Medical-Nikkor is the most current of their designs.

All Medical-Nikkors have a ring light flash incorporated into their design. Powered by either the LA-2 (AC) or LD-2 (DC), the flash has enough power to illuminate subjects at 2:1 with maximum depth of field. The flash is built-in to the lens and encircles the front element. Two cords attach to the front of the lens barrel, one is the power cord and the other is the PC connection.

The flash does not have TTL technology. Instead it uses a

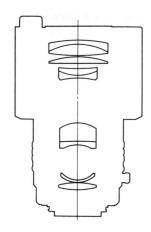

Nikkor 120mm f/4 IF Medical

Guide Number system such as the old 45GN. As the lens is focused at different distances, the lens automatically sets the aperture based on the focused distance. There are many drawbacks to this system which current TTL technology handles better. Exposure compensation is best manipulated by changing the ISO on the camera. This makes for quick calculations and speedy return to zero compensation.

The 120mm Medical focuses from 1:11 to 1:1 by itself (it cannot focus to infinity). By attaching its own special Auxiliary Close-up Attachment, the lens focuses from 1:0.8 to 2:1. The lens has a built-in focusing lamp so focusing can be easily performed. It also displays through-the-viewfinder magnification and ready light. The magnification can be imprinted on the film or turned off.

This highly specialized lens, when first introduced, was very popular because it made many tasks easier. But in the decade since its introduction, innovations such as TTL have made its technology less desirable. Many now use other optics with Nikon's SB-21, for example, rather than the 120mm f/4 Medical, thus, taking advantage of TTL while maintaining greater control over depth of field and exposure.

Nikkor 200mm f/4 Micro IF

Original release: 1981 Angle of coverage: 12° 20'

Unique features: macro of 1:2

Physical size: 2.6"x7.1"

Weight: 28.3 oz.

Filter size: 52mm Lens hood: built-in

M.F.D.: 2.34'

Aperture range: f/4-f/32

A magnificent lens, the 200mm f/4 Micro was all the rage when it was first introduced. Due to the flurry over autofocus it has been forgotten but now many are "finding" the lens for the first time and rediscovering just what a marvelous lens it really is.

It is physically a small lens, its barrel diameter only slightly larger than its 52mm front element. It is very lightweight making handholding extremely easy. The tripod collar can be removed to further enhance using it handheld. And because of its tremendous focusing range, it performs almost like a zoom.

The 200mm Micro can focus from infinity to 1:2 without any additional accessories. The lens incorporates IF so it does not expand or contract when focused, resulting in its fast response to moving subjects. With the addition of a 1.4x converter the lens becomes a 280mm f/5.6, able to focus nearly 1:1 and with a 2x (TC-301 works the best), it's is a 400mm f/8, focusing 1:1. All of this while maintaining a working distance of 2.34 feet!

The original version (AI) had a narrow tripod collar with a wide aperture ring. The tripod collar was perfectly suited for the lens' weight and length. But with the introduction of AIS, the lens collar was made wider and the aperture ring made narrower. For those with large fingers, this posed a bit of a problem.

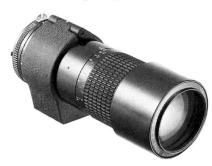

Like all micros, the 200mm f/4 should not be pigeon-holed and reserved for just close-up work. It is a great telephoto, especially for scenic photography.

Nikkor 200mm f/4 Micro IF

Nikkor 500mm f/8N

Original release: 1984 Filter size: 39mm screw-in

M.F.D .: 5'

Angle of coverage: 5° Lens hood: HN-27

Unique features: macro mode Physical size: 3.5"x4.6"

Weight: 29.7 oz. Aperture range: fixed

Nikon has produced mirror lenses since it began manufacturing lenses. They have constantly updated them throughout the decades with the 500mm f/8N being the finest to date. There are many reasons for this which are overlooked as the old stereotypes from previous versions still haunt this mirror lens.

The biggest improvement is in the mirror design. The Catadioptric mirror of the current 500 f/8 N has been redesigned to virtually eliminate all chromatic aberration. Though the lens still produces the typical mirror lens "doughnuts" caused by out of focus background highlights, the sharpness of the lens is outstanding.

But the current version has more going for it than just sharpness. It is physically small, nearly 100% smaller than previous versions. This makes handholding the lens a snap giving it added versatility. It can also focus down to 5 feet! To repeat, it is a 500mm lens that focuses down to five feet, the closest thing to it is the 500mm f/4 at 20 feet.

The drawback is that the lens has a fixed aperture of f/8. Depth of field cannot be increased or decreased with this lens. A 39mm screw-in neutral density filter can be attached at the rear for manual exposure control (making the effective f/stop - f/11), but this has no effect on depth of field. Other filters can be attached, likewise, to manipulate color, but one filter must be in place at all times whatever the case.

The lens works well with the 1.4x converter and marginally with a 2x. The TC-14B can be used with the 500 f/8 by removing the filter which is the preferred method to achieve maximum sharpness. This creates a 700mm f/11 lens able to focus to five feet.

The mirror lens is commonly pooh-poohed by "serious" photographers because it is a mirror. This is a shame as it can be very useful in many situations. In remote camera work where a great deal of magnification is required and there is very little free working distance, the 500mm's minimum focusing distance of five feet is a great option. When working from a canoe where weight is a concern as well as capsizing, this relatively inexpensive lens is a great choice. This holds true for any situation where a super telephoto is required but risking a multi-thousand dollar lens is not advisable. Not that this lens is a throw-away, but it can be a problem solver where no other lens will work.

Nikkor 1000mm f/11

Original release: 1977

Angle of coverage: 2° 30′ Unique features: none

Physical size: 4.7"x9.5"

Weight: 67.1 oz.

Filter size: 39mm screw-in

Lens hood: built-in

M.F.D.: 25'

Aperture range: fixed

The 1000 f/11 has been plagued with the same stereotyping as the 500 mm mirror. In addition, the slow speed of the 1000 mm f/11 has "turned off" the majority of photographers from even trying the lens.

It is a sharp lens; though a dark lens to focus, which hurts it. Only on bright days, when viewing can be accomplished does its sharp image shine through the viewfinder. Its long reach of 1000mm makes it a natural for wildlife photographers, but its "doughnut" shaped highlights are very undesirable. Not because they are unsightly, but because most photographers do not want others to know they use a mirror lens.

Will the current high-quality, fast films save the 1000mm f/11 mirror lens from oblivion? Doubtful, as the fixed f/11 is slow by any standard. Though it has a very narrow angle of view to isolate a subject, the f/11's deep depth of field lets in a lot of the world, nearly negating its isolating ability.

Teleconverters

Tricks of the Trade

Teleconverters once had the stigmatism of being the poor man's telephoto. Quality and reliability were viewed as having been scarified in order to save a buck. Though never true of Nikkor teleconverters, this stigmatism spilled over on them. It was not until Nikon introduced the 600mm f/4 with an accompanying TC-14 1.4x teleconverter did this all change. The TC-14 was not sold separately at first, but demand was soon so high it was made available.

The quality of the TC-14 was so good that Nikon's 2x teleconverters were finally taken seriously. Always expensive as far as teleconverters go, their optics matched their high price. Today, using a Nikon teleconverter is not only an accepted practice, but quite often a means of solving photographic problems that no other tool can solve.

Nikon produces only 1.4x and 2x teleconverters. The TC-14A/B are the 1.4x and the TC-201/301 are the 2x teleconverters. The lenses these teleconverters can be matched with have always been a confusing point. The rule of thumb that is normally quoted (TC-14A & TC-201 for lenses up to 200mm, TC-14B & TC-301 for 300mm and longer) is a loose fit at best.

The TC-14A and TC-201 have recessed front elements. The front element of the TC-14B and TC-301 protrudes out past the lens mounting flange. This is what you should go by when matching up converter and lens (there are exceptions to this with the new AF converters). A lens whose rear element is flush at its rear should be matched up with the TC-14A and TC-201. Lenses whose rear element is inset in the rear use the TC-14B and TC-301.

There are some exceptions to this, for example the 200 f/4 Micro, which most use with the TC-201, works best with the TC-301. The 500mm f/8N mirror lens works best with the TC-14B with the rear filter removed. The TC-14A and TC-201 can fit on and work with lenses whose rear element is inset, but often vignetting or loss of sharpness at the corners occurs.

Teleconverters do change the lens' effective f/stop. The TC-14A and TC-14B suck up one full stop while the TC-201 and 301 suck up two. This means a lens with an f/stop of f/2.8 will effectively be an f/4 with the TC-14A and B and an f/5.6 with the TC-201 and 301. The teleconverters also affect the lens' angle of view by 1.4x or 2x, corresponding to which is in use. The reproduction (magnification) of a lens such as a micro is also 1.4x or 2x greater. But the depth of field is decreased by 40% with the 1.4x, half with a 2x, of the lens in use. Depth of field is not increased, nor is it the same as another prime lens equal in focal length to the lens and teleconverter combo.

This is one of the main reasons the teleconverter is used by pros. A longer focal length lens is acquired with greater isolation properties. A narrower angle of view and depth of field makes a super telephoto even more valuable as a tool. Such combinations as 300mm f/2.8 with TC-14B (becoming a 420mm f/4), 500mm f/4 with TC-301 (1000mm f/8) and 600mm f/4 with TC-14B (840mm f/5.6) are common throughout all disciplines of photography.

Are there any tricks of the trade to teleconverters? The one I just illustrated is it, but it is a biggie. It can apply to any lens and be used almost anytime. The exception are zooms. Except for the 180-600mm, 200-400mm and other ED zooms, zooms do not perform well with a teleconverters attached.

Except with the F4 camera, matrix metering is lost when using a teleconverter. This is because teleconverters (except TC-14E and TC-20E) do not have electronics built into them to maintain communication between body and lens. The AF-I lenses, on the other hand, do not work with older teleconverters and must use only those matched to work with their electronics.

The TC-14E and TC-20E are the newest teleconverters. They are made specially for AF-I lenses and are not meant for use with any other lenses. The TC-14E is the 1.4x and the TC-20E is the 2x. These teleconverters maintain full operation with all Nikon AF bodies and AF-I lenses. The only exception is the 600mm f/4 AF-I and TC-20E. AF operation requires an effective f/stop of f/5.6 or faster. The 600mm f/4, doubled has an effective f/stop of f/8. This is beyond the range of the sensor so it cannot work in AF with the TC-20E.

This portrait of the smallest owl in North America, the Northern Pygmy Owl was taken with an 800 mm f/5.6.

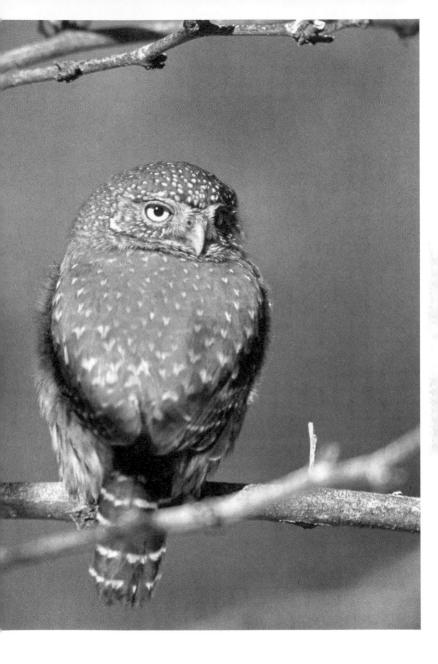

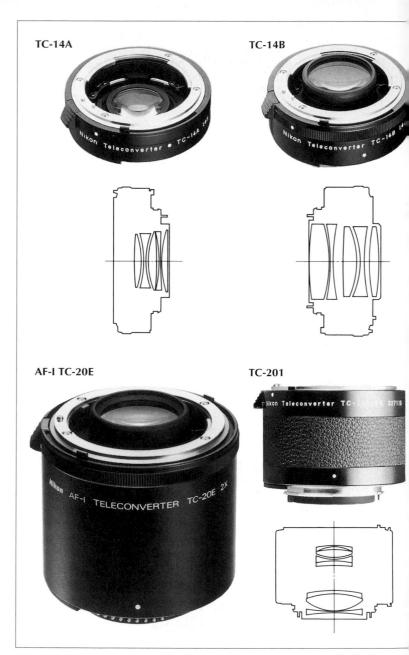

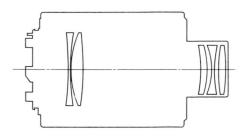

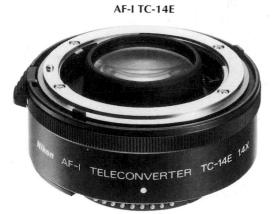

Nikkor TC-14A

Original release: 1984 Filter size: none Angle of coverage: 1.4x of lens Lens hood: none

in use

Unique features: none

Physical size: 2.6"x1"M.F.D.: same as lens in useWeight: 5.1 oz.Aperture range: f/2.8-f/45

A marvelous teleconverter, it works well on short focal length lenses. One of the best uses of the teleconverter is in macro work. For example, when used with the 60mm f/2.8, nearly 2:1 magnification is reached. It also works well with the 75-300 zoom, an exception to the rule.

Nikkor TC-14B

Original release: 1984 Filter size: none Angle of coverage: 1.4x of lens Lens hood: none

in use

Unique features: none

Physical size: 2.6"x1.3"M.F.D.: same as lens in useWeight: 5.8 oz.Aperture range: f/2.8-f/45

A very expensive teleconverter, it is well worth every cent! This teleconverter is in wide use on every possible Nikkor lens. Finding them either new or used can be difficult because of their popularity. There is not a lens that it works with that is not improved due to its use.

Nikkor TC-14E

Original release: 1993 Filter size: none
Angle of coverage: 1.4x of lens Lens hood: none

in use

Unique features: works only with AF-1 lenses

Physical size: 2.6"x1" M.F.D.: same as lens in use

Weight: 7 oz Aperture range: f/2-f/32

For owners of AF-I lenses, the announcement and then release of this teleconverter was music to their ears. Those owning the 300 f/2.8 AF-I were probably the happiest as the addition of the TC-14E makes it a killer 420 f/4 AF-I that many can hand hold.

Nikkor TC-20E

Original release: 1993 Filter size: none
Angle of coverage: 2x of lens Lens hood: none

in use

Unique features: only with

300 & 400 AF-I

Physical size: 2.5"x1.8" **M.F.D.:** same as lens in use **Weight**: 12 oz. **Aperture range**: f/2-f/32

As few have put this teleconverter to the test yet, not a lot of feedback is out on its popularity or performance. Since doubling super telephotos is not as common as just adding a 1.4x, use of the TC-20E will be limited until other super telephotos such as the 500 f/4 are introduced as AF-I. Since the 500 f/4 is one of the favorites to be doubled, its AF-I release will bring out great stories of the TC-20E's performance.

Nikkor TC-201

Original release: 1984 Filter size: none Angle of coverage: 2x of lens Lens hood: none

in use

Unique features: none Physical size: 2.5"x2"

Physical size: 2.5"x2" **M.F.D.:** same as lens in use **Weight**: 8.1 oz. **Aperture range**: f/2-f/32

One of the most commonly owned Nikkor teleconverters, the TC-201 has been used on every possible lens. And since it can work on every Nikkor lens, there really is no limit to the problems in photography it can solve. For many years, it was the way many got to 1:1 magnification with the 55mm micro. It is a marvelous teleconverter worthy of all the praise it receives.

Nikkor TC-301

Original release: 1984 Filter size: none
Angle of coverage: 2x of lens
Lens hood: none

in use

Unique features: none Physical size: 2.5"x4.5"

Weight: 9.9 oz.

Lens hood: none

M.F.D.: same as lens in use **Aperture range**: f/5.6-f/64

This is probably the least owned of all Nikkor teleconverters because it is designed for super telephotos whose owners normally do not double. The exception is the 500 mm f/4 which is regularly transformed into a 1000 mm f/8.

A nighttime shot of a Pacific Chorus Frog taken with a 60mm f/2.8 \bigcirc Micro.

"Oldies but Goodies"

No one will argue that Nikon has always manufactured some of the world's finest optics. Many of its lenses, though out of production for a decade or more, are still found in photographer's bags. Some of these lenses are nearly impossible to find used and thus, demand an incredible selling price when available. They are truly Nikon's "oldies but goodies."

Many of these "oldies but goodies" are previous versions of current lenses written up in this book. For example the 35mm f/1.4 and 180mm f/2.8 have been killer optics since they were first introduced . This includes earlier versions of lenses listed in this chapter as well, the 55mm f/3.5 for example. Many early manual lenses are still extremely popular with today's photographers.

This list by no means covers all of the magnificent lenses in Nikon's past. Instead, it concentrates on those lenses still found in a majority of camera bags, or lenses still in high demand from the buying public. Others are lenses that have magnificent optics which can only be found used at a high price. Finally, some of these lenses have been stereotyped unfairly, preventing many from buying them. We'll dispel these myths so that others will be encouraged to try their incredible optics.

Nikkor 55mm f/2.8 Micro

Original release: 1982 Angle of coverage: 43°

Unique features: focus to 1:2

Physical size: 2.5"x2.4"

Weight: 10.2 oz.

Filter size: 52mm Lens hood: HN-3

Lens hood: HN-3

M.F.D.: 3"

Aperture range: f/2.8-32

Probably no other lens is as responsible for getting photographers involved in exploring their natural world than the 55mm f/2.8 Micro. Even those owning other brands know of the reputation of this lens. However, this reputation was not earned just in macro

photography, but as an all around lens delivering remarkable quality.

The 55 f/2.8 incorporates Nikon's CRC system. This is the key to its sharpness when focused at 1:1. This edge-to-edge quality is legendary, well known as being "hair splitting." Although the CRC is not supposed to be in effect when the lens is focused near infinity, whether it is or not, the lens maintains the same edge-to-edge quality.

Getting to magnifications greater than 1:2 requires an extension tube of 27.5mm. Nikon makes the PK-13 specifically to match up with the 55 f/2.8. The PK-13 is exactly 27.5mm and maintains all meter and aperture couplings. To reach 2:1, adding either two more PK-13s or a 2x teleconverter is required. In either case, meter coupling is maintained which is important since two stops of light are lost for each 1x increase in magnification.

There is a scale on the lens barrel which has caused more confusion than it has solved. Looking at the barrel, one sees "m," "ft" and "PK". The "m" is for meters and is basically ignored by most U. S. photographers. The "ft" is relative when the lens is in use directly mounted to a camera body. It indicates distances in feet until getting down to 1:10 magnification at which point it counts down to 1:2. The "PK" scale starts at 1:2 and works its way down

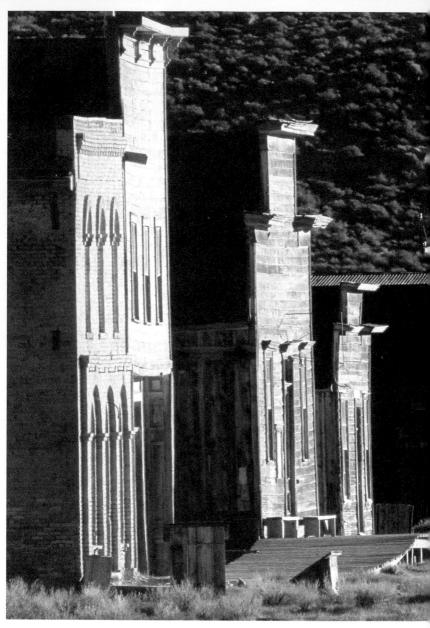

An old street in Bodie State Park lit by the dawn and photographed with the $800 mm\ f/5.6$.

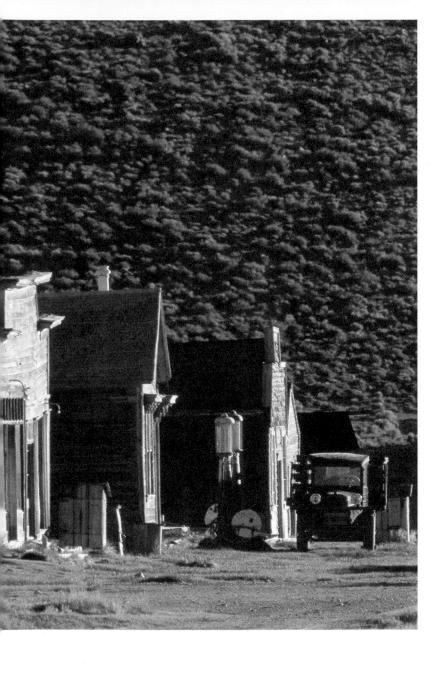

to 1:1. This indicates physical distance between the lens and subject when the PK-13 tube is attached to the lens.

Now, years after this lens has been discontinued it still resides in hundreds of thousands of photographer's camera bags. This is even after the 60mm f/2.8 swept the current new lens market. This is a testament to the quality and lasting ability of the 55mm f/2.8 Micro. And in a fickle marketplace such as photography, that is saying a lot!

Nikkor 105mm f/4 Bellows Lens

Original release: 1969 Filter size: 52mm
Angle of coverage: 19° Lens hood: none

Unique features: designed to

work on bellows

Physical size: 2.5"x2.0" **M.F.D.:** 6"

Weight: 8.1 oz. Aperture range: f/4-32

This remarkable lens was the original 105mm micro. It was designed specifically for use on the PB-4 and PB-5 Bellows. On the bellows, the lens can be focused from infinity to 1.3x. On its own, it cannot be focused as it has no focusing ring. It has a completely manual aperture having no automatic diaphragm linkage. In 1969, it was high tech and very specialized, qualities that have kept it popular and in demand today.

The 105 Bellows Lens is extremely sharp. Even when used at high magnifications, it maintains sharp corners even though it is not a "flat field" lens. Since it has no helicoid, it depends on the contractions and expansion of a bellows for focus. When used on a bellows, typically it is preset for a specific reproduction (magnification) size so the entire bellows/lens/camera set-up is moved to focus on the subject.

Operating the aperture is the same as with a PC lens. Aperture readings can be taken anytime (if used with a bellows, add in the bellows factor) by manually stopping down the lens. The aperture on the 105mm Bellows Lens clicks on 1/3-stop increments (the only Nikkor lens to ever do this). A second ring can be turned and set at the predetermined f/stop so the aperture can be opened up for focusing. The lens must be manually closed down though, when the photograph is taken.

On the bellows, it has an outstanding free-working distance of 6" at a magnification of 1.3x. But the most popular use for the 105 Bellows Lens (referred to as "short mount" 105) is reversed on a telephoto lens such as a 200mm f/4. Attached via a 52-52 adapter ring, this combination produces a magnification of 7x with a free working distance of 4"! The aperture on the 105 Bellows Lens should be wide open for optimum results. Metering is accomplished by using the aperture on the main telephoto lens. It is recommended that this lens not be closed down past f/16.

Because of its tremendous flexibility and free-working distance, few if any of these lenses can ever be found in a camera store. Those that do show up normally cost four to five times the price of the lens when it was new! This is because it is a marvelous tool for the close-up photographer surpassing many options available in today's modern lenses.

Nikkor 300mm f/2 ED IF

Original release: 1984 Angle of coverage: 8° 10'

Unique features: fast

Physical size: 7.2"x13"

Weight: 266.3 oz.

Filter size: 52mm

Lens hood: HE-1

M.F.D.: 13'

Aperture range: f/2-16

At the 1984 Olympics a new lens appeared on the track. It couldn't be hidden as its 160mm front element shined in the sun. The 300mm f/2 made its debut while photographers from around the world gathered with all their big super telephotos to capture the events. And for many photographers, the biggest event was the introduction of the 300mm f/2.

At the time the lens was discontinued, it was a special order item with a Suggested List Price of \$22,000! Used, they still command a high price, high demand and high respect. This has a lot to do with the lens being so sharp, especially at f/2. It also has to do with its ability to isolate a subject better than any other lens. Most of all, it has the allure of being the fastest of the fast.

The lens is huge! At over 16 pounds, it weighs in as one of the top two heaviest lenses ever manufactured. Most of this weight is in the front element making the lens extremely front heavy. This takes "a little getting used to" which slows down its operation until one gets into a set routine to handle the weight. Once accomplished, its very bright image and IF make operation extremely easy, even in very dim light.

The 300mm f/2 was always sold with a dedicated teleconverter, the TC-14C. The teleconverter sucks up one stop of light and increases focal length by 1.4x. It converted the lens into a 420mm f/2.8 that focused down to 13 feet and was tack-sharp. This dedicated teleconverter was needed to preserve the edge-to-edge quality when the lens is shot wide open. The problem of uneven exposure due to vignetting is possible with all other Nikon teleconverters. This includes the TC-301.

Nikon states its use as, "Ideal for indoor sports, action photography and all types of available-light shooting." However, this is barely the tip of the iceberg for applications. Many wildlife photographers, fashion photographers and others have found this lens to be the only way to take photographs. Truly one of the rare Nikkor optics, shooting through it is a remarkable experience with its very bright image and pinpoint focus.

The tricks of the trade for this lens include being able to afford it, that is, after finding one to purchase. Having large arm muscles to maneuver it and the imagination to make the most if its ability to isolate doesn't hurt either. Think of it, the depth of field of f/2 with the angle of view of 300mm. Its life as a new product might have been limited, but it will be in the field for as long as Nikon makes cameras.

Nikkor 300mm f/4.5 ED IF

Original release: 1979

Angle of coverage: 8° 10'

Unique features: IF

Physical size: 3.2"x7.6"

Weight: 37.1 oz.

Filter size: 72mm

Lens hood: built-in

M.F.D.: 10'

Aperture range: f/4.5-32

Until the 300mm f/4 AF came on the market, the 300mm f/4.5 ED IF was the 300mm to own. Its reign as "the" lens lasted for over a decade mostly because of its versatility. This has taken the lens into every possible arena of photography with great success.

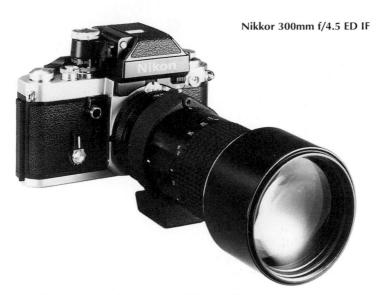

For this reason, thousands still find homes in photographers' arsenals of lenses.

The 300mm has a tripod collar that permits 360 degree rotation. It is removable which facilitates handholding for many. Many also use it on a gunstock for extra stability. In either case, its internal focusing gives a quick response to any subject. This is further enhanced by its small focus ring throw of just a little over 100 degrees.

Because of its lightweight, compact design, many use it in conjunction with a TC-14B. This makes a handholdable 420mm f/7 with limited depth of field. This isolation and portability has made it one of the preferred lenses for nature photography but its versatility for the nature photographer goes beyond this.

Another excellent application of this lens is with extension tubes. For example, by adding an PN-11 and PK-13 (80mm of extension) to the lens, it has the magnification of 1:2 with a three feet free-working distance. Depth of field is a slight battle as the extension tubes have moved the lens away from the film plane, but the image quality is outstanding. One application for this would be in photographing wildflowers.

With the introduction and wide acceptance of the 300 f/4 AF, used 300mm f/4.5 ED IFs are available at reasonable prices. For

the budget-minded photographer, this is an excellent opportunity to get a marvelous lens. The trade-offs between the lenses are too few to even mention in one sentence. The benefits though are greater than can be described.

Nikkor 800mm f/8 ED IF

Original release: 1979
Angle of coverage: 3°
Filter size: 39mm
Lens hood: built-in

Unique features: none
Physical size: 5.3"x17.8"

M.F.D.: 35 feet

Weight: 123.8 oz. Aperture range: f/8-32

An obscure lens, the 800mm f/8 ED IF is one of Nikon's better kept secrets of all time. The optics of the lens are quite sharp and have been overshadowed by its f/8 speed. It is also haunted by the previous 800mm f/8 lenses which where not ED IF, and were physically very long and slow. The original 800 f/8 was a two-part lens with a tremendously long focusing throw and very dark view. The majority of lenses which made the trek from a two-part system to ED IF also got faster, but somehow the 800mm f/8 didn't.

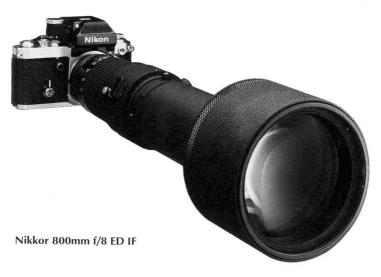

The 800mm f/8 is a remarkably well-balanced lens. This is important as the focusing ring is behind the tripod collar where a hand should rest for correct long lens technique. The lens is basically a narrow tube, with only the front element end diameter being a little larger than 122mm. The elements take up very little room in the barrel which is mostly air space. This is what makes the lens so well-balanced.

With fast lenses being so important, 800 f/8 lenses can be found at almost give-away prices. It might take a little looking to find a used one though, as those who own the lens rarely let go of it. Many of these are wildlife photographers who use the lens on a gunstock. Its balance and weight make it easy to use, especially when stalking wildlife. Its light weight also makes it an excellent choice for close-up photography. The lens works great with extension tubes with the PN-11, reducing the minimum focusing distance to 27 feet.

One recommendation is to get rid of the case supplied with the lens. Its the same case used for 1200mm f/11 and is really oversized for the 800mm f/8. Long Lens Bags by Domke® work much better, not taking up as much space while providing lots of protection and quick access.

Nikkor 1200mm f/11 ED IF

Original release: 1984 Filter size: 39mm Angle of coverage: 2° Lens hood: built-in

Unique features: none Physical size: 5.3"x22.4"

Physical size: 5.3"x22.4" M.F.D.: 45 feet

Weight: 146.3 oz. Aperture range: f/11-32

The secret "weapon" in many prominent wildlife photographers' arsenals, few exist in the marketplace. Its predecessor, a two-part lens, though extremely slow, was very popular. This popularity was due, in part, to the tremendously long reach of the lens and its very narrow angle of view. The longest lens in its day, its reach had a romantic appeal as well as problem solving abilities. Other than the 2000mm f/16 mirror, this is the longest lens Nikon has ever made.

The 1200mm f/11 is physically very long. It is basically a tube

Nikkor 200-400mm f/4 ED

with glass at the front element and then one other group just in front of the tripod collar. The rest of the lens is an air gap making up the focal length. With the element group being right in front of the collar, the focusing ring cannot be near it. Consequently, the focusing ring is at the rear of the lens which makes using correct long lens technique difficult. The lens is well-balanced though, which aids greatly in operation.

Nikon said of the 1200 f/11, "The king of super-telephotos." They go on to say, "ideal for sports, wildlife, and frame-filling shots of the sun or moon itself." With a staggering 24x magnification compared to a 50mm lens, the 1200mm can pull in and isolate like no other. The fact that this lens has been totally absent on the used lens market even though its been discontinued since 1988 almost defies the odds. This is because not only were few of these lenses manufactured, but those who own them never get rid of them. This is the highest tribute a lens can receive.

Nikkor 25-50mm f/4

Original release: 1980

Angle of coverage: 80° 10'

to 47° 50′

Unique features: none

Physical size: 3"x4.1" Weight: 22.5 oz.

Filter size: 72mm Lens hood: HK-7

M.F.D .: 2'

Aperture range: f/4-22

This is an amazing zoom! It fits that magic comfort range of 24-50mm in a nice small package. At its introduction, fast lenses were not in high demand. This is reflected in its constant f/4. It is a two-touch or two-ring lens. One ring zooms and one ring focuses. This was one of Nikon's first two ring zooms and the big selling point was the focus would not be accidentally changed during zooming.

This was Nikon's first wide angle zoom which made it very popular from the start. The price though, kept it out of reach of many general photographers. It was not until Nikon closed out the lens when it was discontinued that the masses got to see what the few owned. This is incredibly sharp from corner to corner. Whether focused at its minimum focusing distance or at infinity, the edge-to-edge sharpness rivals prime focal length lenses.

The lens is a marvelous tool for scenic photographers. Whether shooting overall grand views or close-ups, this is a one lens arsenal. Its 72mm filter size accepts Nikon 72mm polarizers with rear filtration being a simple option for color correction. It also works marvelously with extension tubes, with the PK-11 creating a magnification of 1:4.

With the advent of autofocus, many manual lenses have been abandoned. The 25-50 was one of the first to go, but smart photographers snatched them up so that today, they are almost impossible to find. This is a lens' biggest tribute and a sign that it is something special.

Nikkor 50-135mm f/3.5

Original release: 1984 Angle of coverage: 46-18° Unique features: macro mode

Physical size: 2.8"x4.9"

Weight: 26.2 oz.

Filter size: 62mm Lens hood: HK-10

M.F.D.: 2'

Aperture range: f/3.5-32

A zoom with a limited range, the 50-135mm has always had a big fan club. There are numerous reasons for this, the biggest is the fact that the lens is extremely sharp throughout its entire range. Another is its rather compact design. This was wrapped up in an affordable price range making it accessible to all photographers.

It fits a range that was temporarily void of coverage by a zoom. Many purchased it quickly, finding extreme versatility in its compact range. Its minimum focusing distance instantly made it a big hit, especially when coupled with a 5T or 6T. The lens is capable of 1:2 magnification with two feet of free-working distance. The image quality, when used in this way, is rather remarkable, especially since it's accomplished with a zoom.

Another endearing fact about the 50-135mm is that the front element does not turn. This is advantageous when using a polarizer, an important factor since the lens is very popular with scenic photographers. This is further enhanced by its minimum f/stop of f/32.

Nikkor 50-135mm f/3.5

When Nikon announces that it has "discontinued" a lens, there is a feeding frenzy to buy any remaining stock. The 50-135 was one of the biggest of these frenzies as some photographers stocked up on multiple units. Today even with faster, greater range and smaller zooms, the 50-135 is rarely found used in a camera store. It is one of those mythical legends Nikon is known so well to produce.

Nikkor 80-200mm f/4.5

Original release: 1970 Angle of coverage: 25-10°

Unique features: none

Physical size: 2.8"x6.4"

Weight: 29.3 oz.

Filter size: 52mm Lens hood: HN-7

M.F.D.: 4'

Aperture range: f/4.5-f/32

No other lens was as responsible for making zooms a viable photographic tool than the 80-200mm f/4.5. Going through a number of optical refinements through its long run, the final version was probably its finest. But this is a judgment that splits hairs at best since the changes are just refinements in the element coatings.

The lens is a one-touch, push-pull zoom. It is a true zoom, with focus not changing during the zooming action. This is important as many focus at the 200mm setting then zoom back

Nikkor 80-200mm f/4.5

for the proper framing. This action is not a problem as the lens is so well-balanced, with all action fitting the hand perfectly. All of this, combined with its remarkable optics made the 80-200 one of the most popular zooms ever manufactured.

It did not fare well with teleconverters though. The combination of all the glass caused a drop-off in quality, especially at the edges. The lens was also hardly ever used with extension tubes as that was not a common practice in its hay day. Today, many use it in this manor with excellent results.

The number of 80-200s that were produced was staggering. Even so, very few can now be found on store shelves. True, their use by photographers is a fraction of what it once was, but most photographers refuse to let them go. Whether it's a connection with a glory time in photography, a trusted friend, or for backup when the modern stuff breaks, the 80-200mm f/4.5 has a hold on photographers like few other lenses.

Nikkor 200-400mm f/4 ED

Original release: 1984 Filter size: 122mm

Angle of coverage: 12° 20′ to 6°10′ Lens hood: HE-2 Unique features: none

Physical size: 5.7"x13" **M.F.D.:** 13'

Weight: 136.9 oz. Aperture range: f/4-32

A lens that came and went quickly, the 200-400mm f/4 is more popular today than when it was available new. I remember camera stores with this lens new in stock, selling it at cost just to get rid of it because it wouldn't sell. In 1984 dealer cost was \$2470, but today some have bought this lens used for just under \$10,000!

It is a great lens, producing beautiful images that are tack sharp. Its flexibility and bright image have made it a mainstay for wildlife photographers. In fact 90% of the 200-400s are used by wildlife photographers. They have found these to be one of the best lenses for big game with the focal length and f/stop isolating and complimenting the mighty giants of our landscape.

It is commonly used with the TC-14B. This makes the lens into a 280-560mm f/5.6 zoom! It is in this mode that the lens

becomes a great tool for bird photography, especially nesting birds. The flexibility is so tremendous and the quality so hair splitting that the lens is able to command a high price in stores.

The rising sun and a 300mm f/2.8 caught this Simpson's Hedgehog Cactus blossom opening for the first time.

From Silver Pixel Press

Also by B. "Moose" Peterson. . .

The Nikon Guide to Wildlife Photography

Ever wonder how the pros capture the stunning pictures we admire in the finest outdoor magazines? Is so, look no further than this new book by B. "Moose" Peterson.... Not merely another text on wildlife photography this book stands out among the competition because of three factors: extensive use of photos with detailed explanations, the significant emphasis on field ethics, and Peterson's explanation on how each species can be located, attracted or tracked... This is a virtual gold mine of information that will surely become an invaluable asset in increasing your success ratio of high impact images."

Peter K. Burian Outdoor Photographer magazine.

Magic Lantern Guides

....take you beyond the camera's instruction manual.

The world's most popular camera guides; available for most popular cameras.

Magic Lantern Guide to the Advanced Nikon System

"I can't imagine a Nikon aficionado being without a copy of this book. It is essential equipment! Not only does it cover every Nikon camera likely to be of current interest to the serious photographer, it offers complete coverage of the all-important Nikkor lenses and accessories."

Bob Shell,

editor Shutterbug Magazine

From Hove Books!

Nikon Compendium

by Hillebrand and Hauschild The name "Nikon" means the same in any language a universal camera system that is unique in its scope, reliability and, above all, in its continuity for over thirty The authors of the years. Nikon Compendium have provided in one book a comprehensive guide to this vast Nikon system. Here is the guide that describes virtually every item available on the general market, aids identification, give tips on using it and explains just what fits with which and what the limitations in usare when cameras. age lenses or accessories from one generation are married to items from another.

Nikon Rangefinder

by Robert Rotoloni

The complete history of Nikon's 35mm rangefinder cameras, lenses and accessories. Interesting reading for anyone wanting to know more about the early days of this great camera company.

All books are available from your dealer or write for a complete catalog from Saunders, 21 Jet View Drive, Rochester, NY 14624.

Get A Bunch Of Photojournalists Together To Talk Equipment, And There's Probably One Thing They'll Agree On...

The Bag.

DOMKE

A Division of THE SAUNDERS GROUP

21 Jet View Drive, Rochester, NY 14624 TEL: 716-328-7800 FREE FAX: 800-635-0670 Send for our full-color catalog.

In Canada: Amplis Foto, Markham, Ontario

MORE POSITIONS THAN THE KAMA SUTRA

Thanks to the Benbo tripod's unique Quick Lock universal joint design and incredibly versatile monorail, you can set up camera positions that would make other tripods blush. So add a little spice to your photography. Get a Benbo tripod and let your imagination run wild.

Tripods for impossible places.

A Division Of The Saunders Group For a copy of our new full color catalog, call, fax or write: The Saunders Group, 21 Jet View Drive, Rochester, NY 14624. TEL: 716-328-7800 FREE FAX: 800-635-0670